MASTHEAD

MANAGING EDITOR
Jenna Gersie

PROSE EDITORS
Rebecca Bevans
Tyra Olstad
Heather Tourgee

POETRY EDITORS
Anna Mullen
Ellie Rogers

VISUAL ART EDITOR
Anna Martin

READERS
Ashia Ajani
Emma Irving

PUBLISHER
Dede Cummings

COVER ART
"Family Tree" by Beric Henderson
Acrylic on canvas, 59 x 39 in., 2018

FOR QUESTIONS AND COMMENTS
editor@hoppermag.org

hoppermag.org
facebook.com/hopperlitmag
Twitter & Instagram: @hopper_mag

T0155155

The **HOPPER**

A LITERARY MAGAZINE FROM GREEN WRITERS PRESS

LETTER FROM THE EDITORS

As we read through submissions for this issue, Ellie, one of our editors, became pregnant. But even before we all knew her news, featuring Beric Henderson's bright image of a woman and her womb on the cover of this issue made sense. Some might see pregnancy as a threshold into the domestic, into home and safety, not fitting for an issue themed "bewilder." But this woman's visible interior troubles that easy dismissal—she grows another life inside her, blooming and rooting, vining and wilding.

We picked this theme partly for the way the word "bewilder" begs us to break it into a command: be wilder. A pregnant woman cannot forget that her body is wild as the small child beginning inside her grows a shared organ, blunts her illusion of control, and abets desires. Pregnancy is a literal and unambiguous illustration of what many of our readers know: We are not separate from each other. Like Henderson's image reminds us, we are inextricable from pollinators, gnarled trees, and rivers.

The writing and artwork we gathered helped us remember this too. To be bewildered is to be afraid sometimes, vulnerable to storms and other creatures' hungers. You reminded us: the jaw pressure of a wolf is 1,500 pounds per square inch. The hawk will find its mouse. When you carve a fish, its eggs may spill like coins onto the forest floor. Coyotes will find them. This world is wild, and we are of this world. What we call environmental disaster includes us all: the great blue heron in an oil spill and the sister with breast cancer.

Long ago, to bewilder meant to lure into the wilds. Wilderness has signified woodlands and danger, all that is untamed or uncultivated. But our memory can also bewilder, wander beyond certainty. Sometimes, there is will beyond our control—the will of a child, a bee-hungry flower, a lynx. Sometimes we can give up trying to count the snow geese and let the world slide by without our exacting its progress.

Though some places, some experiences, may more easily convince us of our own wildness, no place is depraved of the capacity to bewilder. All our hearts flickered and fledged beneath our mothers' hearts from almost nothing. And the empty sky above you now could become, suddenly, starlings: "a thousand dots, black against blue, a flock / of quickened hearts spilling in the open space . . ."

The Editors

BEWILDER

Writing like trees, writing with trees

toward that dark rest where fog takes the shape of ridgelines
my mind takes the shape of fog and each oak leaf
follows fractal coastline taking the shape of cells
 if I paramecium the mica tongue
 if I awaken the bees
 if I sleep further into marrow
 will foxes panting find shelter in broken
 bracken near springs enough for all

 split between myself and myself is human
 consciousness walking down trail to rock-bed
 wild currents, I'm yellow in places like a swallowtail
 and would like to curl my sticky thin legs on a willow stem
wondering how ink is sap and how the eros of ink is
the literature of bee-hungry flowers

TALLEY V. KAYSER

A Better Animal | NONFICTION

THICK SMOKE from nearby fires greases the sky, smearing the sun to a dark red ball. The smudged gray landscape flares dim orange here and there, where narrow stretches of mirror-smooth granite catch the weak light. Across the canyon behind me, through thinner smoke, I can just see white threads of waterfall snarling down from the edges of cliffs.

I know where I am.

But I do not know where to go.

I consider the dark escarpment ahead: a wall of rock, perhaps fifty feet high, that juts from the steep slope of the mountain and blocks my way, then vanishes into the swirling murk above and below me. I shift my gaze and hunch over the ragged pages in my hand. Leftover rain drips from the hood of my jacket. My finger smudges the print as I read the lines for the twentieth time, out loud, very slowly: "From a grassy gap north of Peak 10,280 (3,125 meters), ascend a gentle hillside west until level with the top of the peaklet, then contour straight across medium-sized talus until reaching a dark bluff."

My voice sounds fuzzed, oddly bounded by my skull; my hearing still hasn't returned. I lift my head, shaking more water onto the page, and deliberately scan the landscape yet again.

Were this another day, those waterfalls behind me could be helpful landmarks. But the falls are ephemeral, unmarked on any map; they were spawned by the three hours of hail that just pummeled this corner of the Sierra Nevada mountains. And, as evidenced by the raw skin on the backs of my hands, pummeled me.

I turn back to the guidebook. My eyes skim over the next few lines, which describe a "fabulous view": a valley where "miniscule groves of conifers harmonize perfectly with shining slabs and glistening brooks." By contrast, the next instructive section is brusque. "A moderate descent from the dark bluff leads down into the canyon," I read, "and the route for the next mile is both obvious and easy."

"Okay," I mumble. "Descent from the bluff. Come on." My thoughts grind slowly. *Descent from the top? I can't climb that wall. Not with a forty-pound pack. I could follow the wall down. But is that the right canyon?*

I check my watch—6:47 P.M. An hour before sunset. I shift, and the rocks I stand on shift in turn, reminding me of the unstable talus I need to cross safely before dark. *Maybe I could go higher. Look for a place to cross the bluff . . . get caught in the dark. At eleven thousand feet, on talus, this tired. That's asking for a broken ankle. Should I go down, then? Descent from the dark bluff . . .*

I know where I am.

But I do not know where to go.

That circumstance, for me, is unusual. I've spent over a decade accumulating outdoors skills. After more than forty thousand hours of professional, in-field wilderness experience, I am better-than-average qualified to guide not only myself, but you, your children, and/or your most treasured parent into and out of wild places.

Wild places. What does "wild" mean? Certainly not "untouched by humans." I've walked into Alaskan wilds via ATV-churned mud roads, found abandoned vehicles in the middle of the Mojave, and bumped into research equipment in remote pockets of the Rockies. Humans build facilities, manage invasive species, cut paths through, conduct research in, and otherwise alter every designated wilderness area in this country. That's in addition to our historical impacts on ecological systems and the large-scale impacts of our eagerness to burn the carbon-rich remains of ancient organisms.

Each year, I walk a small group of college students through the history of American wilderness, challenging received ideas about wilderness and introducing arguments that complicate our shared adventures. "Wilderness is an elitist idea," I say. Or, "Wilderness is ableist. Wilderness is racist." Often,

students express fascination with a particular point environmental historian William Cronon makes: that "wilderness embodies a dualistic vision in which the human is entirely outside the natural." And yet, no matter how cynical I become about the word "wild," I—and the students in my classes—continue to believe wilderness has value.

Likely, that's because we actually go there.

For many of the students, our multiple-day backpacking trip is their first exposure to wilderness. As much as I encourage them to interrogate wilderness, my greater hope is that they continue to explore it. I hope even as I know that their conclusions about wild places may be very different from mine. Why *do* I value wilderness? I am still answering that question, and still answering it by going on walks. As often as I can, I spend stretches of days in mountain wilderness; as often as I can, I spend them alone.

Thus: this route. Wander solo for two hundred or so miles in the Sierra Nevada, mostly above ten thousand feet. Climb up thirty-three passes, ascending roughly twice the height of Everest over the course of the trek—and then scramble immediately down each one, through snow and/or scree and/or ankle-breaking talus. Most significantly: avoid trails. Instead of following a path, route-find through the rugged terrain with a set of maps and guidebook. *From a grassy gap north of Peak 10,280 (3,125 meters), ascend a gentle hillside west until level with the top of the peaklet . . .*

Go wild.

The route is demanding, but my journey has been relatively smooth. I've re-routed small sections to avoid the wildfires ravaging California this summer, and nigh-daily storms slow my progress, but until this afternoon I've adjusted to conditions without much trouble.

Yesterday, for example, a hailstorm pinned me to a hillside around 4:00 P.M., just as I was poised to enter "labyrinthine granite corridors" under a boiling sky. I pitched my yellow tarp in good time, taking advantage of a clump of juniper and pine. While hail whipped into the tarp and thunder rattled loosely between the ridges, I rested, content with the simple pleasure of good shelter in heavy weather. When the sky settled a couple of hours later, I tucked into my sleeping bag unruffled, sure I could make up lost mileage in the morning.

And the morning started well. I moved through the granite corridors easily, approaching my next destination—an impossibly blue lake—earlier than planned. I forded the lake and headed into the next stretch with confidence. But more convoluted terrain drew me off-route within an hour. By then, the clear morning had become a smoky afternoon. As I backtracked, I failed to consider that the thicker-than-usual firesmoke had clouded the sky, making it difficult to monitor for storms.

Thus, I was above eleven thousand feet, crossing a steep tongue of bare boulder and rock between two high peaks, when the first thunder screeched through the smoke.

I do not like storms. I gain satisfaction in preparing for them: in reading the sky well, in setting up my tarp effectively, in staying dry for as long as the storm persists. I savor, too, the post-storm emergence: the sudden first birdsong, the ozone-invigorated atmosphere sharp and vivid. But the storms themselves are a different matter. I do not rejoice in them; I endure them.

Sierra literature, by contrast, describes storms with boundless enthusiasm. Guidebook author Steve Roper, for example, offers this breathy description of the classic cloudburst:

". . . thunderheads shoot up with amazing rapidity to altitudes as high as 35,000 feet. The temperature drops abruptly, a brisk wind springs up, and the sun disappears behind seething gray shapes. Thunder growls in the distance, and then the heavens explode. Tendrils of lightning lick nearby summits. An eerie darkness contrasts with the glistening hail pounding the earth. Crackling ripples of thunder foretell of impending detonations that echo forever off the cliffs. The gods seem to have lost control of their domain, and all is chaos."

In a similar vein, indefatigable John Muir glories in "big, bossy cumuli" and "silvery zigzag lightning lances," in rain "fitted like a skin upon the rugged anatomy of the landscape." Not to mention the thunder: "gloriously impressive, keen, crashing, intensely concentrated, speaking with such tremen-

dous energy it would seem that an entire mountain is being shattered at every stroke." Characteristically, Muir is unconcerned that *he* might be shattered, even as he describes 200-foot firs that lightning "split into long rails and slivers from top to bottom and scattered to all points of the compass."

Sierra storms are relatively mild; the chances of getting struck by lightning are much lower than the chances of, say, freezing to death on Denali. But unlike many of the explorers I read, I cannot entirely shrug off the danger inherent in weather. Even as I set up shelter, tuck my gear away, and get into the defensive squat known as "lightning position," the skin-and-nerve bundle of me is keenly aware that I can neither predict nor control atmospheric conditions.

This is instructive.

The more time I spend in wild places, the more I realize that my lived experience of wilderness leaves no room for Cronon's "dualistic vision," for the human self as distinct from capital-N Nature. Human privilege is, of course, inherent in my walks: I am in the mountains by choice, I can (theoretically) leave them at will, and I bring tools that increase my comfort and safety. But the actual space of the mountains, the walking through them, blurs binary distinctions between human and nature with every step. When I solo, I am as exposed as any creature to a lightning strike, or a broken bone, or a falling rock. Regardless of accumulated competence and excellent gear, my lived experience of wilderness is an experience of *vulnerability*.

I'm no rugged individual conquering the wild; I walk in a hyper-awareness that can, and does, veer into fear. And if I fail to stay aware—fail to sense a storm behind the smoke—a wild place can quickly put me in mine.

This particular thunder caught me by surprise. Moreover, it caught me in a dangerous place: exposed, high, and hard to hurry from.

I immediately turned from the peaks and down, picking my way from boulder to boulder, suddenly awake to the energy sizzling above me. The rocks I crossed first shone wet with rain, then bounced merrily with hail, then rattled louder and louder as the hail grew in size. I hunched my shoulders and focused on my feet, which flashed chiaroscuro. Banshee thun-

der shrieked between the peaks, screamed down the slope I walked, and wailed over the canyons below, clawing at their walls.

Again.

Again.

My teeth chattered. The boulders slickened with ice. I moved down the jumbled rocks, in the only direction I could go without going up a ridge or into the storm. Down and away. Down and away.

Until I approached the edge of a cliff.

I stood in a chute about thirty feet wide, with a wall of jumbled rock on either side. The declivity sloped, gradually but certainly, into the edge of a canyon perhaps a half mile wide. A cluster of three small red firs hugged the southern wall, their roots clutched tight to the rock. I crouched beneath them, hoping the lightning and thunder would slacken. It increased. The hail grew larger, pummeling bruises into my back.

"I need more shelter," I muttered eventually. My voice made no sound amid the racket—just buzzed in my chest.

I stepped from the partial protection of the firs, wincing at the renewed force of the hail. The wind and falling ice slowed my progress; my hands fumbled familiar hitches. But in time I pounded the last stake into a bare patch of sand and ducked under my protective tarp.

Inside, the noise of the storm doubled. Hail hammered the yellow fabric hard and fast. In moments, the tarp bulged inward with ice, threatening collapse. I crouched again, face toward the wind, and extended my arms to support the fabric. Swipe left to clear the hail. Swipe right to clear more hail. Left. Right. Left, right. Lightning tore at my eyes. I kept my breathing steady, but it grew ragged. Hail gathered at the rim of the tarp in a pearly white wall and gathered into pearly peaks at the corners.

An hour had passed since the first thunder. The storm would last two more hours. I would spend that time in my defensive squat, shivering and clearing hail, muttering self-encouragement, until the wind yanked a corner stake from the sand and whipped it painfully into my shoulder.

The vulnerability I'm lauding—solitary, hyper-aware, open to terror—seems to fall into the

aesthetic category of "the sublime," wherein overwhelming terrain inspires mingled fear and awe. I certainly gravitate toward sublime landscapes: "vast, powerful landscapes where one could not help feeling insignificant and being reminded of one's own mortality," as Cronon puts it.

But "mortality," and the sublime, emphasize the soul. "Sublimity," writes wilderness historian Roderick Nash, "suggested the association of God and wild nature," and Cronon agrees that for the Romantics that canonized the sublime, "God was on the mountaintop, in the chasm, in the waterfall, in the thundercloud." Even in secular company, talk of wilderness blurs into talk of the spirit, of the self found and fulfilled. In wild landscapes, the story goes, the soul experiences a kind of bigness-induced vertigo, teeters into awe at its smallness, extricates itself, and walks away with a mighty *wow!*

Awe, wonder, smallness—these are essential to wildness. But as far as I'm concerned, they have nothing to do with God, and even less to do with the soul.

I internalized this at age nineteen, during my first-ever hike. The trail ascended three thousand feet in three miles; it led to a peak unlike anything I had experienced, where great cliffs roughened the foreground and mountain after mountain carved the horizon sharp and stark into the utmost limit of distance.

At that age, I was supposed to pray at beauty. I tried, to great discomfort. And alongside the swifts that zipped through the thin air winged a pair of new, strange thoughts:

This place is older than God.

This place is older than even the idea of God.

Those thoughts are a part of me, now. They swoop through my chest every time I am tempted to pray for safety, or say that a physical obstacle has helped me "find myself."

Wilderness is not my cathedral. Wilderness certainly doesn't perch pieces of my inner self on peaks for me to collect, like so many spiritual trophies.

Wilderness pays me no attention at all.

Instead, wilderness demands all of my attention. Wilderness insists that I consider food, water, shelter, rest, the chance of injury, my fleshiness. The vulnerability I feel in wild places is entirely unselfed, entirely unsouled.

It's not mortal, but *animal.*

•

I gritted my teeth at the sting in my shoulder, then lunged for the stake and pulled it to tension, restraining the walloping fabric. Hail forced me into a hunch. I spotted a bare patch of sand, grabbed a rock, and hammered the stake in. My hands and hair streamed water; hail flayed my knuckles open. I kept my head down and focused on the task, on breathing steadily.

I briefly glanced up from my work as I finished. But at that precise moment, a bolt of lightning
 —orange and purple-thick and liquid, almost slow—
 jagged naked from the clouds cracked against the
 rim of the canyon
 and seared my vision entirely white.

If what I'm seeking is vulnerability, surely I don't need to walk two hundred miles through mountains. I could run alone at night. I could read more news. I could head approximately thirty miles southeast, where fires gnaw at California's wild-urban interface. There's no shortage of ways to experience bodily dread from within civilization.

But dread, of course, is not the point. You don't need to find God/self in the wilderness to see how vulnerability entwines with wonder; the wonder is the vulnerability, the self humbled by and entangled in a living world that does not cater to its image.

In wild places, I marvel at my animal kin. Flies zip past my head, whizzing with vigor through thin air I struggle to breathe. A black bear eases through streamside willows with enviable, muscled strides. Water ouzels fly the contours of a stream, then fly into and through the snow-cold water as though it were air. A toad hops, surprising as a dinosaur, from beneath a rockshadow at twelve thousand feet. Migrating butterflies, hundreds of them, stream across high passes and over snowfields, batting aside turbulent wind as though only flirting. "Humility," in a space inhabited by the *wild deor* that give wilderness its name, blurs into "respect."

And then there's the land itself, which shapes me into a better animal. In the first two days, I write poems. In the next twenty, I write: food, water, shelter, terrain, and rest. My journal consists of the space and my movement through it.

"What if thought," asks philosopher David Abram, "is not born within the human skull, but is a creativity

proper to the body as a whole, arising spontaneously from the slippage between an organism and the folding terrain that it wanders?" It takes time. But after several days in the mountains, my brain and my quads remember that they speak the same language, that they are the same body. And it's a whole body/mind/self that wanders the folding terrain, whether scrambling through talus or strolling a streambank . . . or learning the taste of lightning.

The thunder *shook* me. My jaw went numb. My hands convulsed. I screamed.

A moment later, I confirmed that I was breathing.

I was also kneeling. Blindly, I felt for the edges of the yellow fabric and ducked under.

My vision began returning, in antlike swarm. Hail pounded down. I stared at my bleeding hands. I crouched, and rocked, and repeated soundlessly:

when this is over (breathe)
the sky will be so blue (breathe)
you won't believe (breathe)
it ever happened (breathe)

Some of my students contend that wilderness is a frame of mind. That by attuning yourself to wonder, you can have wilderness anywhere: by holding your hands under an open tap, or considering the bacteria in your gut, or taking a walk around your neighborhood and admiring light in the trees. After all, they point out, wilderness is subjective. A hiker might "feel" wilderness only a few yards from a trailhead, long before crossing any designated boundary, and plenty of urban spaces can feel like wilderness.

I encourage these meditations. They de-privilege wildness, open it up to all bodies and all places, complicate the stereotype of the rugged explorer dashing into the woods and emerging triumphant. They bring nuance to our discussions and apply a critical lens I consider integral to any responsible conversation about wilderness.

But.

When my shelter collapsed, I sat still for almost three minutes.

Which is quite a long time to be tangled in sodden

material under full hail. My head was bowed. I looked at my hands.

I said, "This seems unnecessary." I still couldn't hear my voice.

It was hard to get out of the tarp. The hail kept pounding down, weighting the fabric where it pooled around me. I shoved hail aside and aside and eventually crawled from under the sodden mess . . . and squinted through the still-oncoming hail as I registered the changes in the landscape.

On my left, a torrent of brown water churned and snapped at the hail that fed it. On my right, a second torrent of brown water pounded the roots of the red firs, threatening to wrestle them from the rock.

I was hunched on a single raised finger of land, perhaps fifteen feet wide, framed by rapid and rising waters that met in a snarling heave and tumbled over the cliff into the canyon.

I was on all fours, half-tangled in fabric, in the middle of a waterfall.

I may never be able to tell this story well. Told well, there would be no trace of familiar arc—the rising action, the climax, the resolution. There would be no hero (here, a heroine) emerging safely from the storm.

Instead, there would be a steady pressure of event, simultaneously numbing the senses and scraping them raw, until you feel what it is like to sit in the middle of a waterfall in equal proximity to terror and laughter and wonder all at once, and to not have a single thought.

The best I can do is to keep walking.

I looked ahead, where the brown water continued to thrash over the edge of the cliff and down, pockmarked by hail.

I looked behind me. The narrow strip of land mounted higher: a way out. I turned to my work.

I plucked and hauled at my tarp until it was free of hail, then shoved it into the outer pocket of my backpack. I shouldered the soaked pack, then climbed up the narrow finger of hail-slick rock, into the storm.

The storm eased. Thunder wailed in fits, then trailed into a quiet that hummed in my skull. No blue skies emerged as I worked back on route; fire still greased

the sky, and red light bounced eerily from polished rock. The hail that crusted every surface began to melt, pooling and spilling, clicking in intricate rhythms. It sounded like chattering teeth, or a swarm of insects clacking tiny, myriad jaws.

Unable to cross swollen streams, I shoved through tangles of willow. Blood continued to trickle through the creases on the backs of my hands; I hissed when leaves scraped the tender skin. My ears whined with thunder-echoes. My throat was raw from the lightning-scream, and would stay raw for two days.

When I paused for breath, I watched the white tangled threads of water just visible in the distance, numbly acknowledging that—shrouded in smoke, surrounded by lace-like webs of cliff-caught hail—they were new and strange and beautiful. Then I walked on.

All the way to this dark bluff.

I need thought. I need thought like I need the muscles in my legs and the alveoli in my lungs. The guide-book, the map—these human tools, these products of thought, are essential.

But my tools do not separate Brain from Body or Human from Nature. The thoughts I turn to the map are bodied. They are the fleshy movements of a brain in a place, using its cultural skill as an animal sense. My brain is as caught in place as my throat; my self is an animal that needs shelter and rest before dark. I am not separate from world.

My culture pushes this truth away, insistently. Our stories tell us that wild places exist to serve us—to offer us God, or a frontier in which we can prove our skill, or tourism dollars. In the Lower 48, where less than 3 percent of land is designated wilderness, critical approaches to wilderness emphasize human control: that we designed wildness, we define wildness, and we protect it from ourselves.

We tell this story—I teach this story—at risk of eliding another truth: that we are vulnerable. That we are as subject to the rules of resource availability, carrying capacity, habitat destruction, and chance as every other creature on this planet. "We cannot abide our vulnerability," as Abram writes. "Vast in its analytic and inventive power, modern humanity is crippled by a fear of its own animality, and of the animate earth that sustains us."

In our stories, we forget that we are animals.

When wildness speaks—in thunder, or another of its tongues—we remember.

At the dark bluff, of course, I consider none of this.

I look at the guidebook, and back at the landscape. I eye my watch. I eye the bluff. The smoke shifts, and the light turns gold, and I glimpse the canyon below.

Miniscule groves of conifers. Shining slabs. A single, glistening brook.

My laughter tangles with the chatter of restless hail. I shoulder my pack, and I walk. ❧

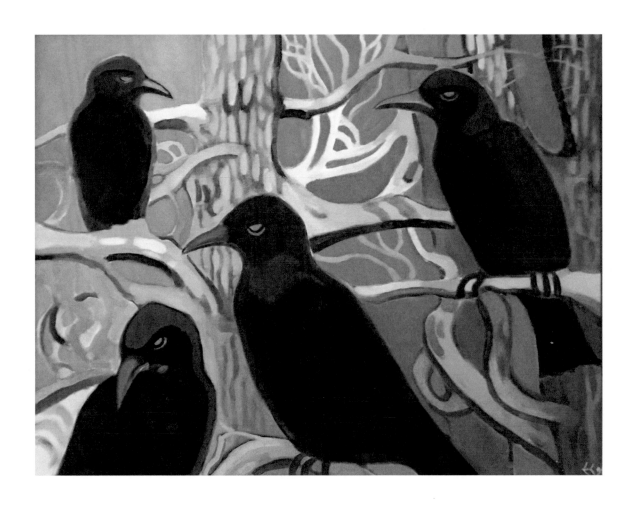

A Gathering of Crows | ERIKA CONNOR
Acrylic on canvas, 18 x 24 in., 1999

ERIKA CONNOR

A Feather from the Crows | NONFICTION

W HERE DID IT ALL START, my following the crows?

It was in Montreal, on Mount Royal, the beacon hill that had given the city its name, where the French had installed an illuminated metal cross and where First Nations people had once lit fires. I was looking down at the city shimmering chrome and glass in the heat, a young artist with sketchbook under my arm. The world lay before me, but I didn't care. I was lost.

THE SPELL

There was a tree full of crows. They were all gathered there like anchors, ink black bodies in the gray limbs, so dark, but with a buoyancy in them, satin surfaces, iridescence, indigo, midnight blue, heads poised just so, mesmerizing. My eyes lit up. There it was. I ran home with the image clutched to my heart, and took out my paints. That was the beginning.

They were everywhere at once, on the news, in films, on radio commentaries. They were the underlying soundtrack, interspersed between a conversation on the street, a telephone call, a child's laugh, a siren, a pause in thought—and no one noticed. I saw them from bus windows, from the canyons of office towers, and as I emerged from the underground. They appeared when I thought about them, then disappeared again. The more I searched the more they escaped my grasp. They always seemed to have somewhere better to go. Were crows always like this—elusive, evasive?

MY CHILDHOOD HOME

For many winters, I stayed at my father's house while he was away in Mexico. This was my childhood home at the edge of a vast provincial park. I had always been a loner. This was why I lived so well in books and thoughts, alone among the trees. The forest was my sanctuary. I spent more time there than anywhere else.

So it made sense that one morning I was woken by a voice, when the sky was still and black. I got up and went into the woods. I was following a beautiful song, one I could not place, and I had to know who was sing-

ing. High at the top of a cedar tree was a solitary crow. I had never heard anything like it, a kind of water fluting sound, with harmonics and breathy notes, warbling. Who would believe that a crow could make such an achingly sweet song?

MATING DANCE

One gave the salute, *crrr, craa, craa,* then banked suddenly on the left, pulled in his wings hard, spiraled down like a spear, and at the last possible moment was caught on some cushion, rising swiftly on a current. The other crow followed, in her ode to the sky, a dance that lingered long after they were gone, over eternal forests, marshland, and valleys.

The Norse god, Odin, had given an eye to the well of wisdom in his unending quest for deeper vision. His two ravens became his eyes and were sent out across the perilous space between the living and the dead. This is described in *Grímnismál*, a collection of anonymous Icelandic poems of the thirteenth century.

"Hugin and Munin fly each day over the spacious earth. I fear for Hugin that he come not back, yet more anxious am I for Munin." Munin was memory and Hugin was thought and of the two Munin was most precious.

Every day the pair flew, wing to wing and one over the other, on each other's backs, then the bottom one folded in his wings and dropped like a stone and the other one freefell. They made their harmonic half notes, *hu hu,* sonic water sounds, throat singing. They mated for life.

FLIGHT

I began finding black feathers, traces of the passings of both crows and ravens. I had a collection of feathers, from both left and right wings, primary and secondary flight feathers, some covert feathers with tufts of white down, and a few long tail feathers. I kept them in a birch bowl made by my brother, among many other feathers from different birds, but the crow and raven feathers were my prized possessions.

Corvidae is their family name. Ravens are the larger birds with tufted collars, curved powerful beaks, and wedge tails, and they can outlive the crows by many years. It was said that ravens preferred the wild, while crows excelled in the city. But I had seen ravens and crows at home in both habitats. They were the same and they were different. I loved them both. Ravens flew across the open with pure confidence. They had few predators. They had loud and deep-throated voices. Their young sounded like a mob of monkeys. Crows were secretive and complex. Their nests were burrowed deep within the pine trees. Ravens made their beautiful bell and water sounds, which crows could also make but only, it seemed, in private. When the crows were ready to nest, they went quiet. They disappeared.

The apple trees bloomed and the raucous screeching of four raven fledglings echoed on the cliffs above the lake. I snuck up on them. Each time the wind came, they seemed to blow off the edge and disappear. Then they rose again. They didn't seem to mind that I was there. They were testing their wings, swooping over me, turning their rudder tails, tilting and wavering. They went out over the lake and came back, using me as a landmark, a witness. I could hear the wind in their feathers. I felt their joy.

RIVER CROWS

Over the years, I lived off and on along the river. I walked for hours down the train tracks, in a place of pine trees, oaks, and sumac, meadow flowers and birds, goldfinches, sparrows, blue jays, and crows.

One day a woman came walking towards me, wondering why I was laughing.

"Crow babies, in the middle of that pine tree. See them? You can hear them a mile away."

"Really?" She looked up at the trees, with a hand shielding her eyes. Maybe it had never occurred to her. The little black birds warbled and squawked like cartoons as the mother came to fill their beaks. They stumbled along the branches. One day they were in a pine, and next day they were in the golden tips of a small oak, fidgeting, picking at lichen, picking at their feet. I watched one trying to preen. He ruffled his feathers a little too hard and fell off his perch. He caught his fall on a lower branch. The other one was pulling little branches toward him, seeing how they sprung back.

A storm was blowing over and a reedy wavering voice was calling to the thunder and rush of rain and wind. I could hear the young crow through the screen door. In the storm's wake came the sun and all the green glittering and the drone of bagpipes carrying from the boat club on the island. The music was tentative at first, and the crow went quiet. Then the piper found the surge and spirit, standing alone on a rock over the water. He was not alone. The adolescent crow was answering, singing along.

LANGUAGE LESSONS

Aaw aaw aaw aaw aaw aaw aaw.
Silence.
Aaw aaw aaw aaw.
Silence.
Aaw aaw aaw aaw aaw aaw.
A second crow flew in and landed in the same tree. It said, *Kaw kaw kaw kaw.*

The first crow, in staccato, pronounced: *Kaw-kaw-kaw-kaw-kaw.*

The second crow, higher in pitch, called: *Kaw kaw kaw kaw!*

I quietly opened the door and came out.

A third crow voice sounded somewhere to the right: a deep throated *kaaaw!*

The first crow flew off, followed by the second one. The third crow flew in the other direction. Minutes later, I heard the clear whistle of a hawk.

They had a certain language with hawks and owls. I once found a great horned owl because six angry crows called my attention, swooping and screeching, leaping from branch to branch, having a tantrum. The great owl sat very still and quiet in their midst, staring with yellow eyes, swivelling his feather-tufted head.

The crows had sky battles amongst their kind. They had a language for dogs, humans, or unidentified objects. They made strange rattling and clicking sounds, tapping their perches with their beaks, or sliding their beaks side to side along a branch. Sometimes they were silent, flying elegantly through the forest, dipping under and over branches, never hitting their wings. Or one would balance on the very tip of a tree, swinging gently to and fro, and if I turned my head for only a moment, it would be gone as quietly as it came. But there was one sound I had never heard before, a kind of mewing or cooing. It happened with a mated pair I found. One was bowing its head, showing the white nictitating membrane of its eye, and the other was gently preening its head.

It didn't take long for the crows to come. They'd been watching the blue jays taking peanuts from my balcony banister. I kept very still, peering through the window. They always knew I was there and they didn't trust me. One was braver. He clutched the peanuts in his claw, and stuffed them one by one, as many as he could fit, into his open beak. A smaller one hovered on the edge, taking any peanuts that fell and flying away with them. One day, the bigger one was cooing on the banister. He did a dance, bowing his head, dipping his beak up and down. He made that sound, a soft mewing, begging sound, and flew to a nearby tree. I came quietly onto the balcony and sang the same wavering tones he had taught me. He looked at me, blinking his inner white eyelid. Would it disturb him or send him away? He bowed his head and cooed back from his perch. I felt the sound on my skin, resonating. It was the first time a crow answered me.

MOLTING

The crows floated with gaps and holes in their wings, losing their rags for something new. They swept the lawn in search of peanuts, blue jays in tow. They came down and sat on the backs of lawn chairs, or swung round and round on the feeder, with wings out for balance, filling their throat pouches with tiny seeds. One had a crippled foot, curled up like a fist. It never opened, even as he hobbled across the ground.

"You like crows?" the woman next door asked.

She was gardening and there was a crow squawking loudly in the tree above at her dog on the road.

"I love them." I smiled at the look on her face.

"Well, I don't. Take them with you."

"I wish I could, but they go where they like."

They were a measure of moods, the way they appeared at certain times, calling into question where you were or what you were doing.

The river was gray, mauve with mist and coming night as I walked along the train tracks. I could hear crows screeching down in the gully. Two flew out from the trees like they had been sent out or were escaping. I crept down the bank. I couldn't see anything at first through the bush, but one crow was still in there, cursing up a storm. Then I found an opening in the leaves and saw a bat floating in sleepy circles, a flickering gray-blue, a trick of the eyes in the cave light. What was going on? I felt uncomfortable and backed away. Strangely, the bat followed, coming straight for me. I

ducked and it swerved, flickering over my head and out onto the river. The crow came out next in the exact same place and almost flew into me. We both shrunk back. He tilted his wings sharply and sped away along the tracks.

Half the time I had no idea what they were doing or why. They watched me as much as I did them. They were composite creatures, clacking and chattering like parrots when annoyed, or waddling, striding in the grasses like chickens. They were cats making a soft *mew, mew* as I came along the tracks, what they used as endearments between themselves with bowed head, or when they were begging. Were they teasing? Was it for me? I always went quietly, trying not to stare too much or they would leave. It seemed to me that they were the shiest of birds, for ones with such a raucous reputation.

I was always looking for them, standing on some road, glued to my binoculars. People drove by with their windows down, slowly scanning the horizon, caught by the mystical air.

"What is it?" they whispered.

"Crows."

They made a sound of disgust, a wave of a hand, dismissal. I was always hurt by this. The car sped away.

People saw the black feathers hanging from my car windshield mirror as a kind of armor or provocation, a leaning towards darkness. Crows were dirty, scavengers. They were ill omens, signs of death and battlefields. But this was a disassociation, a relegation of things either to darkness or light, night or day, when all things were equally part of the whole.

AIRPLANES

Once I saw a crow watching a remote-controlled toy plane fly back and forth over a meadow. He was watching from the top of a pine tree and he stayed a long time in silence. I wondered what he thought. I had heard that crows were superstitious.

CITY CROWS

I heard a crow talking to himself as he dipped his bread in a puddle. I smiled. He muttered and flew up to a low branch.

Craaa. He had left his bread by the puddle.

Then he flew down so close I swear he wanted to brush my shoulder. I felt the wind of his passing.

Another time, I biked down a side street and a crow came out of the blue and rode along with me, on level

with my shoulder. We looked each other in the eye and parted ways at the stop sign.

I began another experiment. I wanted to know if the crows could read my mind. Each day I biked down to the park and sat for hours on the bench by the river. Can you hear me? I asked three crows in a giant willow. Two flew off a branch and dove down through the trees, clucking and moaning, flitting to the river and back again. The third one came dancing towards me, cooing, swept past the park bench where I sat, not ten feet away, and banked over the river. It made my eyes water.

Then I understood: I had let them in. The black birds were my satellites; no matter where I was or where I travelled to, there they were.

The Artist's Crows

On a cold day in December, I was leaning against the building of the art gallery, smoking, waiting for people to come to my show, "Land of Blue Sky." I had just finished hanging all my paintings of a land I had dreamed about since I was a child and finally reached. Across the pure blue sky, two crows danced above me. They made the honorable salute, closing their wings and opening them again, so that they dipped down and up, turning on a wing. Then they flew in slow revolutions, rising higher and higher into the atmosphere. Suddenly two hawks flew out from the heights of a golden building. There was a battle. The crows gave chase and all flew westwards, disappearing over the cityscape. One lone crow returned, golden light on his belly and wings, and when he was just above me he dropped a single white down feather that landed at my feet.

Crows of the Wild Bird Rehabilitation Centre

I don't remember how I found this place. It was a little cabin in the forest on the outskirts of the city. It housed all kinds of birds: seagulls, geese, hawks, vultures, loons, owls, warblers, and starlings, birds that had been injured and needed repair before they were released back to the wild. I came as a volunteer.

The young woman I was learning from held a crow with cracked feet in a towel on her lap. The white rings in the black skin filled with pus and had to be dug out while they bled. The crow lay there, blinking her eye and the white nictitating membrane, occasionally whimpering, a claw clutching the towel.

"They live hard," the woman said.

Another crow needed wing therapy. The woman grasped his legs so that she could stretch his wing, in and out, to rotate and work the muscles. He squawked softly. She let me touch the wing. I pulled it out gently and felt the feathers rasping. His strength, his fingers.

One was blind, three had broken wings, one had a crippled foot, two had bullet wounds. Then there were the baby crows, the ones that had fallen from their nests, or lost their parents. They were kept in the raptor room, alongside the cages of the owls and the hawks, in a giant screened-in enclosure. Seven little crows sat in a row on their branch perch that was level with my shoulder. They had blue eyes and they peered at me. Sometimes they hopped onto my shoulder, as naturally as if I were a tree. Little creatures with tufted tails and mangy feathers and beaks too big for their bodies. They had lost their mothers. I was not a mother, but I could sense the age-old pull to feed them, animal to animal.

Waah, waah, waah! went the deafening chorus.

I pushed the stick into their open red beaks and the meat slop went down their gullets with loud garbling sounds. One crow sidled down the perch to my shoulder, staring with translucent eyes almost blue. He picked at my sleeve. Then all went silent and when I turned again the crow babies were fast asleep.

The adult crows kept secrets and caches in the cracks in the walls, under the bedding. They concocted a powerful musk. I made up cages with fresh pine needles and thick branches from the forest. I had a turquoise towel to move them, but soon tossed it away. The one with the blue-bandaged wing kept unwrapping the towel from her head, her beak open, but never once did she bite me. She played dead, rolled over, and lay there until I turned her over like she was a turtle. The other one landed on my forearm. I carried him out slowly like a king on his throne. He weighed heavily on my arm. At the doorway he hopped off. When I tried to carry him off again the other one gave me a gentle beak nudge. *Don't take my friend.* They were strange and distant. I couldn't quite read them. Their silence was deafening. They left claw marks on my arms. They were sharper and stronger than they believed. That was why I loved them. They were like me.

How could they be linked together? The battle cries of the winged warriors to the silence of the captive ones? The freewheeling never-bow-to-human crows and these soft, still, fearful black dolls? They could not tolerate captivity. It made them fatalistic.

Some were freed and some were sacrificed, with bullets in their shoulders, or wings that never mended, put to the needle, to eternal sleep. The last one lay on her belly behind her perch, with head low, eyes still, quiet as a mouse.

I had touched a crow with my living hands. I had scratch marks on my arm and hands to prove it. I had carried a crow, soft as a dove, stroking her black silken back. But I was sad for them. They fluttered and flowed in my heart and bowed their silk blue heads.

Animals were not mute, I thought. They were not arrogant or self-absorbed. They asked for our understanding everyday, building their nests on our peripheries. They greeted my house as they flew over. I was part of their territory.

THE ROOST

Thousands—it seemed there was no end to them—filled the sky, flying east over the grids and channels of the urban landscape. I had seen this many times. In a city of one million, did anyone look up? The sun was setting and the crows were lit with copper, glinting wings and bellies. Sky warriors.

BLUE CABIN CROWS

I once lived in a blue cabin in the woods. I used to serenade a crow from my door. I would sing and he would listen from a maple tree above me in the rain and cold. I felt the song gathered at my throat as if it were my own. Why would you ever, in your right mind, trade wings for an earthbound existence?

In the autumn I lay on a white stone in a strong wind. The sky was cloudy but the light made my eyes water. A crow was blowing in the wind currents above me like a beautiful black feathery leaf, scrolled and twirling, tilting, rotating. Now another one appeared and another one. Six crows hovered above me, dancing in the wind in perfect silence. The first one came down low and made slow swaying circles. Then they all blew away.

In the winter I was on the little mountain behind the swamp, following coyote tracks. I heard wind in wings. A raven alighted in a pine tree behind me. I went still. He croaked gently, tapped, went silent. Was he still there? I lay a long time on the snow with my eyes on the sky. Silence. The raven croaked again. Moments later he slipped away.

It was a period of my life I will not forget. I was so close to the black birds. I could drift on air currents and feel my way by the tilt in my wings, the pull of every feather, aligned in its proper way, every one lying one over the other.

I was the offering lying in the sun. I was the girl who spoke the strange language, half-crow, half-human. At the place where the sky opened up and the pines stood like kings, I made up prayers to bring them in. And just when I gave up, listening to silence, one would come floating up above the pines, so close I could see his under-feathers. A loner, croaking softly, followed by two flying wing to wing like a laughing couple on their way to the dance. I wanted to go with them. I wanted a mate and a tribe, to leave the earth in a rush of wind and share the sky with them. ❧

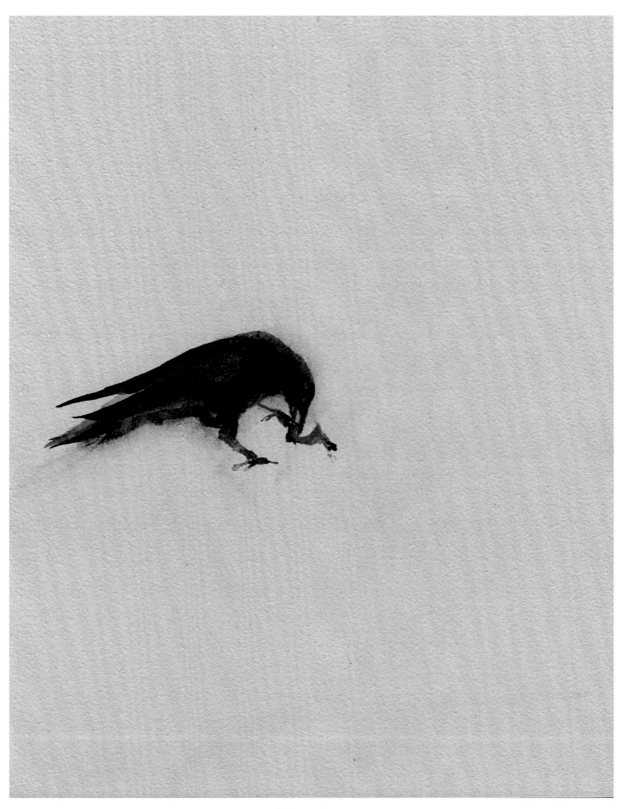

Crow | Susan Solomon
Gouache on panel, 8 x 10 in., 2018

Homestead

Rogue River Valley, Oregon

1.

Above the bed hangs a piece of sky
where a cedar waves its dark arms.
It's said a cougar came
on nights like this
to watch the woman
who slept here, who led lovers
through miles of madronas
on mountain roads,
wild rhododendron
and two steel gates
swinging open and shut
like valves of a heart.

We imagine the cougar
peering down at us, paws
on the skylight's edge,
its body an absence
of stars—

while from the mattress
rises a scent of damp wood, traces
of stories older than us.

2.

A man who wasn't Dutch
they called Dutch Henry
cleared this land, nailed shakes

of cedar into a barn,
watered mules from a tub
by shrubs and wild mint.

He murdered his mining partner
and his wife before he fell

picking apples—shattered
his hip on a thick root.

He's buried where mist
meets the meadow's edge.
The bleak wreckage

of the barn still stands—
nests of nails,
 a single sickle
catching sun
through the rotting roof.

3.

We hang a painting
about the sound of wind
inside two trees,

split and stack wood
by the Fisher stove
hauled up here fifty years ago,

clean mouse poison
from the crooked shelves.

A new wick fits
in the kerosene lamp.

The moon rises,
and bats as small as plums
 slip from the barn's dark seams.

4.

Wasps gather like dew
in the eaves of the deck,

tending nests of mud
sucked from froth
at the river's edge

or spinning paper
from quivering jaws,
their bodies
distended
as blown glass.

5.

You stay up one night
to watch a wasp circle,
frantic, weaving
with a stuttering sound

the high white hive
of the harvest moon.

6.

For centuries this land belonged
to canyon oaks, bracken fern,
footsteps of families
of Tututni and Takelma—

then whites washed
the riverbanks away
with hoses, hunting gold
that was hardly there.

Silt settled in the riverbed's
cool stones, suffocating
salmon and steelhead row—

a generation was buried
before it was born, whole
families vanished into rain.

7.

Settlers herded the last rattlers
on horseback, lighting fires
along Rattlesnake Ridge,

driving them down
to the river's dark mouth
where silt bleeds
into the sea.

All night we dream of hooves
and flame, the living ground
rushing away—and wake

to the hiss of rain
on the loose shake roof.

8.

On the trail a man brags
of riding his bike
from the ridge
to the river's edge—

a dozen snakes, he says,
 lunged into his spokes

but outside of the forest
they turned to sticks.

9.

The tree that felled Henry
still stands, gnarled
by bears with deep, black eyes.

They lope away
when we approach
and watch from the shade
of pines and a gnarled oak.

This earth keeps trying
to tell us something
too quiet for how well we hear—

10.

A west-blowing wildfire
reddens the sun—

ash in windy aspen,
ash in the rake's rusted
teeth against the barn,

bone-white summer snow
dissolving as we cup it—

until a storm, on the eighth day,
sweeps the summit clear.

11.

Past a creek that shines
like beaten tin
we find the dead meadow
where the army kept horses
in the Indian Wars.

At its center stands a rusted can
a local says that a soldier
placed there out of pity—

to water, in the dead-dry
months of summer,
the dazed, exhausted birds.

12.

You water the apples
and a stingy quince.
I harvest wood among tracks
of bobcats and bears,
scat from the cougar
we never see.

At dusk, a family of deer extends
their necks to nose
the overgrown grapes.

Night after night, there is wind
and silence, whispers
and signs of violence. And love
must be different, then—

to make a home
for this whole wrecked world
inside us.

PAUL ANTHONY MELHADO

Queens County Parks: Green Spaces in Urban Places | PHOTOGRAPHS AND TEXT

M Y INTEREST IN LANDSCAPE and nature's beauty derives from the humble existence of nature within the urban environment I call home. How we access the land for our use and how nature preserves itself in this seeming endless cycle of destruction and development is my point of departure in these photographs.

In a densely populated urban environment such as Queens County, New York, humans and nature scramble to maintain their foothold on the land. Often one exists at the expense of the other, but occasionally they find a way to coexist, mostly because of nature's resilience. Queens is home to the largest and oldest tree in the northeast, the Queens Giant, and was once the horticultural center of the Eastern Seaboard. Older parks, like Alley Pond, Forest Park, and Kissena, were formed more than twenty thousand years ago by melting glaciers. Newer parks, like the famous Flushing Meadow, are manscapes created in the 1920s and 1930s. The natural landscape sometimes seems overrun by the visual pollution of Western civilization, but in these urban parks, it appears to have evolved into something more resilient than damaged.

I began looking to our urban parks as a source of artistic inspiration in the fall of 1996, creating an extensive archive of images of the grasslands, wetlands, marshes, and forests that run from one end of the borough to the water's edge. The use of the large format camera and black-and-white film gives me the degree of authenticity and control necessary to interpret the scenes I encounter. Film allows me to record something of my own footprints and the sensation I attach to each encounter, while the ancient equipment allows me to faithfully produce the previsualized image.

In his daybook, Edward Weston wrote, ". . . photography is not all seeing in the sense that the eyes see. . . . the camera captures and fixes forever . . . a single, isolated, condition of the moment." My large format cameras attach me to a tradition known as "straight photography," which, as described by Sadakichi Hartmann, involves relying on your camera, your good taste, and your knowledge of composition, considering as you go every fluctuation of color, light, shade, lines, values, and space, patiently waiting until the scene of your pictured vision reveals its supremest moment of beauty. In other words, I aim to make a single negative that is absolutely perfect and that records the full tonal range of the scene, so that only slight, or no, manipulation is necessary. In previsualizing a scene, I often look for something that reminds and connects a particular scene to the more majestic landscape images of the old masters. With Edward Weston and Ansel Adams in mind, I do my best to glorify the land I hold so dear. I hope to continue to shed a reverent light upon these parks for years to come. ❧

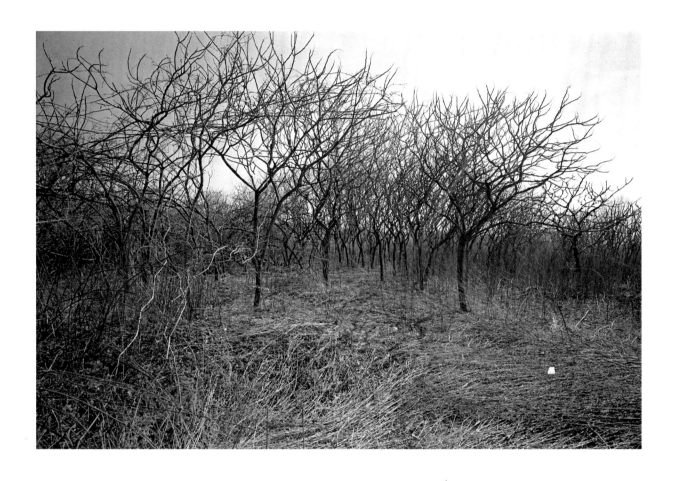

Kissena Trees | Paul Anthony Melhado
Gelatin silver print, 11 x 14 in., 2014

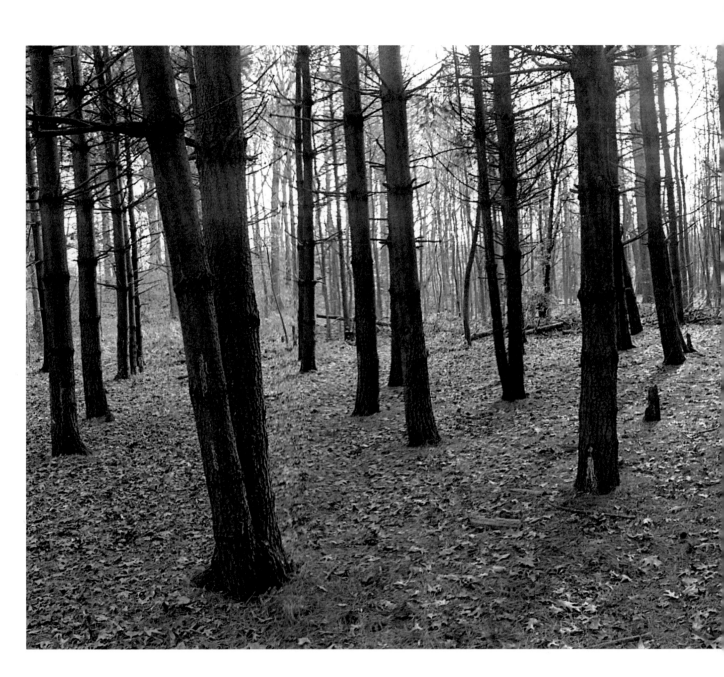

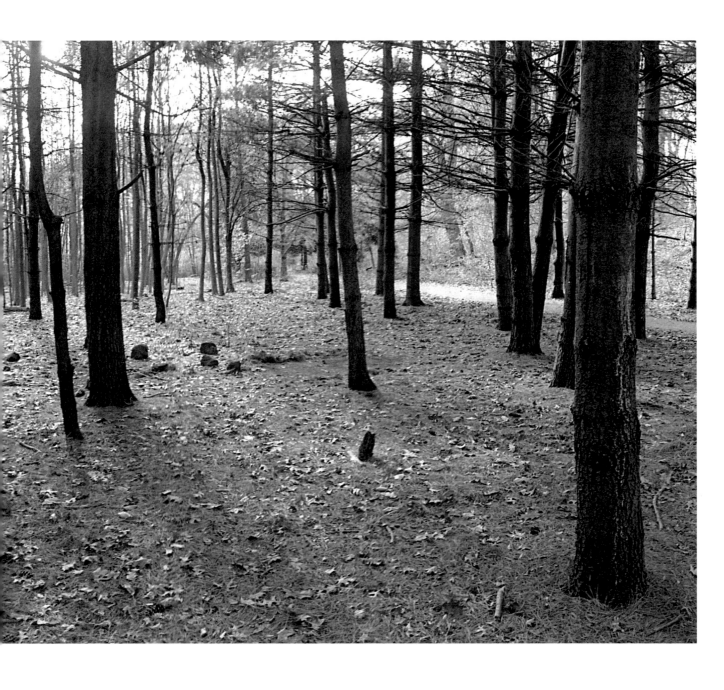

Alley Pine | Paul Anthony Melhado
Gelatin silver print, 7 x 17 in., 2015

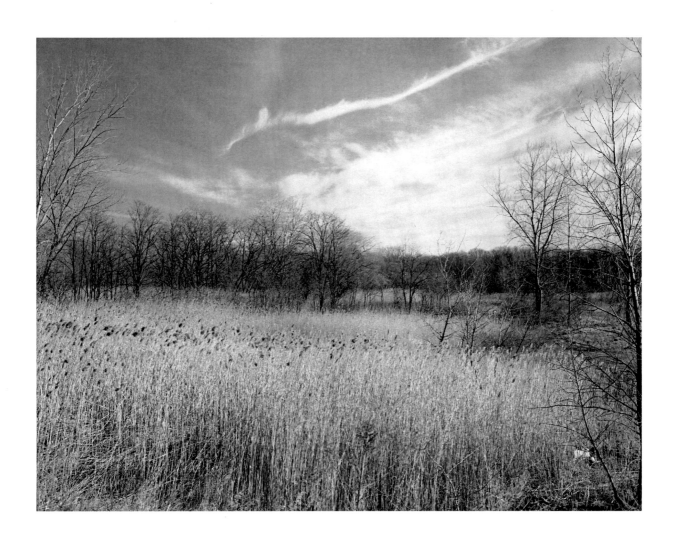

Kissena Back Lot | Paul Anthony Melhado
Gelatin silver print, 11 x 14 in., 2014

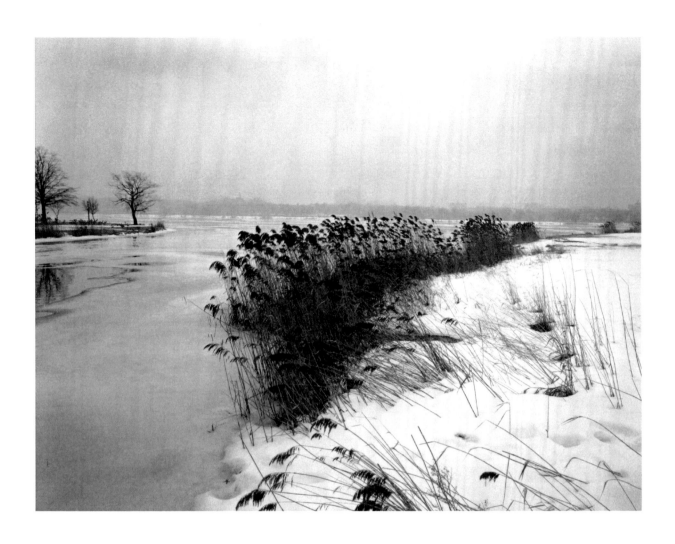

Winter Lake | Paul Anthony Melhado
Gelatin silver print, 11 x 14 in., 2014

TED KOOSER

At Dusk, in December

Driving a gravel road in the country
I saw a hawk fly up out of a ditch
with a mouse in its beak, and it flew
along beside my car for a minute,
the mouse still alive, its little legs
running as fast as they could, and there
we were, the three of us, all going
in the same direction, west, at just
a little under forty miles per hour.

ERIN CONWAY

Stolen | FICTION

I NEVER KNEW MY FATHER COMPLETELY, but I am searching for his story. His garden is my escape. With dirt like scraps of paper, I read its scars through buried seeds.

When the peddler came with boxes, my mother and I could never agree between our four eyes whether he was hunched over and aged or wore an elegant suit. He carried a box that looked as though its strength matched no more than paper. Everything should have fallen out of its layered trays. In fact, everything did, because for my mother, buying was too easy. The twinkle and tinkle of falling seeds reminded me of rain, but such droplets are more often imagined than real, now. I wait for them, their curved and cut edges. When we were finished buying, my pockets felt neither light nor heavy, but my mother's ears and fingers always gleamed.

One afternoon my mother offered the peddler a porch swing to rest upon and a dinner of rice and tomatoes. Full of grains and juices, he rose to leave. Upon turning the key to the engine, his boxes vibrated like the bees who'd left us for faraway alfalfa fields. Electric bulbs flickered sharp yellow and gas breath billowed into my nostrils. My mother and I turned our backs to him. I paused behind her arm that bent to catch the screen door. And then I heard the squeal, the thump, and the silence of death. Stealing a match from the sparse cupboard, I tiptoed to the bodies. They were two ringed robbers with slim fingers in gloved paws. Outside my window I had heard more than once their nails scrape on tree bark as it crumbled. Now I wondered, would I hear the abandoned babies cry? This was the mother raccoon I supposed, and one small soul in her care that followed too close. Where were the others? In the tree? Ahead of their mother? Or behind? The match was spent, but I did not stumble as I returned to the dark porch.

That night I dreamed that the universe had come to see me. But it was my father's face that beamed from beneath the salesman's hat.

"The plants grew in an inconvenient place. Remember how we used to bet which plant would win the sky?" he asked gently.

I did. I could see them inch up and widen as we walked the land together until the moons turned their seeds to flavor in my mouth. The seeds we didn't eat my father had dried across woven planks. The glass jars he named as promises to me. "If the seed is tainted, what will feed you?" he asked before his image faded. I breathed the waning harvest moon. I tucked the clinging scraps of my skirt into ridges across my knees as I watched the orb billow on the horizon and realized that this was what the peddler traded. When I awoke, I was comforted that the too-cool cotton I felt was the sheets.

The cracks in my feet absorb the earth's heat, smoked dirt and crumbled blades of grass too near to ash. I round the corner of the house to find the tree I treasure, the one that guards my window. Last night I heard no cries, but the tiny gray-brown babies may still be nestled in tight.

Smelling rot deep in the bark, I whisper with my head upturned toward what should have been leaves. "Let's run away together." I beg, "Let me follow you." I had heard tales that down the bramble path, I might taste the promise of a forgotten ditch that had avoided both the mower's blade and farmer's spray. I pull a black-and-white picture from my front pocket. It had been folded by my father's hand, the day he yelled into the telephone, "They are not weeds!"

Which they? I had squinted. His back folded, creased inward to itself. He was the photograph.

"You condemn our green space to the mercy of a switch flipped miles away?!" His voice splintered. The telephone cord had snapped like a man hung with his own rope. Condemn?

I strained my eyes to see green as a color not painted but grown. I had sat at the small table, envisioning a summer day when I ran through the irrigator's spray. Though I knew my father would scold me, I had allowed its refreshment to spread across my cheeks the color of roses my mother threw away. I worried so

much about the soft, animal figures too often caught in the road that I had seldom considered the plants that bordered both asphalt and cultivated rows. Distracted by the tickle of summer sweetness on my toes, I had been startled by the scrape of my father's chair.

"They abuse the land to make it reflect their inner scape. When did they change the land? When did the land change them?"

I had nodded because I loved his voice, though I didn't understand his words until the present day, when I find no water to erase the chemical sting from my skin.

I reach into my pocket. In my hand I hold many plants, now slick fibers pressed flat by the camera into history. Today, unlike that day, I can read their one name in the letters scrawled across the photo's back. *Prairie.* Stolen. The many plants in my hand have become only one. Corn was many plants if numbers could be names. The peddler dealt in numbers. Each time the peddler arrived, the space around the house shrunk. I am allowed to see the neighbors' lives and where the road meets the horizon only when the fields are cut.

The corn leaves sweat; they bake me in their oven. My thumb marks the photo's edge. I fan myself to dry the print. The walls of corn, stretched like bars, keep the others out. The chemicals burn the water, and the insects open mandibles to consume my socks. Barefoot, I dig into and across earth. The details of its varied lives encircle me like colored vines. To travel seems a sacred serendipity. Still, so much do I fear flight that I cannot breathe. What I think I can read as air holes cut as stars oppress me at night.

A bright flutter stretches away from me. I repeat their names as my father told them, "Bee. Butterfly," until the crumpled, plastic wrapper catches at my feet. "Raccoons," I call with my eyes clenched tight. Mother calls them thieves. If they left, I could follow them through the ditch, far from the road, and safely through the corn.

Diversity is dead. I know this to be my father's truth, no matter how often my mother selected a multicolored jewel. When the smoke blackened blue and rivers bled rust, my senses rebelled against the curtains the universe drew to blind us. A spell or a die, intention or chance, only the jealous universe knew what was long ago cast. On other days, nicer days, and tranquil evenings I can still hope for those with faith in seeds, that they still believe in the farmer even if he is the plow by which the universe subjugates nature.

"Get the wash! The sheets on the line are dry!" my mother calls.

I rub dust from my eyes.

"Be sure to fold them tight." Fibers too-stretched so that their thinness was sure to rip, I falter, but I do what I am told. I stand. I walk away from the tree. The horizon reminds me of my grandmother's watercolor, beauty from a distance. I almost stopped imagining the liquid blackness of nocturnal eyes, when the sound of splashing cautions my steps.

Two silhouettes are playing. The water tub that barely holds enough to tease dirt and soap from our sheets cups a thin layer in the bottom. It rests at a tilt, turning what was less than half an inch into a bubbly pool. Their nails flick the liquid between their snouts. Each attempts a sip. Then one kisses the other as a second drink. The fur around their mouths darkens as the droplets gather. A sudden flap and smack from a twist of wind jerks their heads to attention. I silence every muscle except my beating heart, but they catch the glint from the metal basket and break away from me into a run. I pray for them to circle and not cut too close to nearby farmers' barns, where all manner of trap or gun would end the tremulous joy barely balanced in the sky between us.

I feel now the warning of my father's words. First we took advantage of the plants, next the animals, and then we set ourselves to dominating each one and then the other.

Unconsciousness scattered our dreams like seed, crossbred with no ancestry to trace. It was not unlike my parents' failed love affair. I had cried for the simplicity of their quarrel and petty jealousy, the hurt and scrape and bite of love, when one felt not enough or maybe was just clinging to the teeniest bit of less. They both wove stories that were shredded by the whip they held and cast upon each other's backs. I am reminded of the stings by my mother's slap when I return at dark instead of dusk with loose and hastily bundled cloth to make her bed.

We lived and we waited among these dead-end seeds sown of false belief. They grew and died. Some bent. Some broke. There were prints scarred across the ground, broken in some places and burned in others. We wore faded cloth but it made no difference; acceptance and indifference required a lesser light. Today

we were not beautiful but we were as I remember it always was. In my father's story, my world had soldiers with sharpened steel tongues. My world had stewards, but they spoke through kind eyes long misunderstood as weakness. The world had believers, but they worshipped words sealed in official letters too easily ripped, burned, or misdirected. I unclip clothespins and fold edges. I tuck in shoulders and arms, waists and ankles. The edges of the sheets are too far. I roll the vast cloth around itself hastily. For now, I watch the raccoons go beyond my reach.

One moon later, the neighbors come to bury my mother who'd disappeared from hunger. One moon more and the peddler drives up to collect his things. In the time between I named the raccoons as orphaned company in this withering house. In better years, there were colors between the shattered jewels. Most ignored them. Fewer named them. My mother had once.

I had only one memory I wished to save. In a separate time, with each rocky step down to wash the sheets, she had repeated, "I always wanted to sleep in a rainbow." With each thump of soap and waves, she had breathed, "I always wanted to walk in the clouds." When she and the peddler took long walks, I saved this memory, in pieces.

I have been conscious so much longer than the others remember. Three of us so close, yet the words from our shared language slip through the ever-growing number of cracks. For weeks the raccoons have shown me how to eat the tanned eggs raw. One was the Fighter who posted his warnings with jagged scratches. The other, the Steward, breathed his silence across the curvature of a noble nose. I was the Believer. It seemed as if, unlike the creator, everything we made came with something missing. It couldn't stand on its own, so we had to patch it and then patch around the patches. That was my family: missing, patched, stolen.

I want to be the mother they lost and a mother for the five seeds that rattle in one of my father's jars. Each meal, I stare across the small table grinding egg in my teeth, longing for the peddler to return. I want to ask him, "What does the glow in the distance mean?" since the neighbors have long since stopped asking anything of each other.

On the raccoons' fifth moon, I wake up tired from my dreams and the grit that I no longer wash from the sheets. It is still dark, just a small light creeping under the door. The rooster's crow is the light at the end of a long tunnel, and the grumble I wish meant rain reminds me I am starving. I had locked up the chickens I could catch before night. Their roost felt so far away. My orphans are too tempted by their feathers and the skin that ripples underneath. The chickens' bones are so light that tomorrow the wind might blow them away. How long would the raccoons stay? My father taught me that when the earth had fallen cold and quiet in winter their practice was to stay together until their first year ended. That was before snow and sun were as one whim, before the scent of dried leaves, and not winter's memory, reminded me of the fire I should have made.

Bits of nothing fall on the roof and now I can't smell the leaves. I am resigned to miss both food and fire. "The wolves are loosed, but there is still a chance to plant a seed. That is what love asks of us." My father's words are zippered in the yellow crust that stings my eyes. I hold my breath and rub the dust away. To how the light fills and excites the day, I pay no attention.

That evening I curl for a womb forgotten, while my eyes scan for silhouettes. The fireworks pop. Pop and pause. And then, a long string of cracks. There is a celebration somewhere. The peddler must have come but not to me. Where did they find the powder? It must have been easier to find than stars. It seemed all the same. I didn't think there was new and old, only sun and rain. I smell the rain. I draw clouds in the dark. The white puffs always block the sun but they don't keep it from coming. Tomorrow the smoke will lift. I think I hear voices arguing in the dark.

My orphans' nails grab and twist, and then sink deep. "Go to sleep," I tell them. "Go to sleep," I whisper to myself. A crash. Thunder? No. I just want to sleep. I have no one's arms to wrap around me. I slip into the kitchen and chase the orphans into the night. Then, I taste blood oozing between my toes. I don't need to know the edges to recognize my father's jar of seeds under my foot. Broken.

"Stolen?" I still hear his defiant voice.

Stolen. There wasn't enough reality here to go around, and for nature there was even less. It was just a field. Some grass. A few survivor trees. Dirt and rocks. Humans could be one with nature; beings could be one with the other. The cardinal directions swirl around me, and I choke on pollen-coated dust. I crawl back into the bed. The sky is one clear breath. In the gaps I hear the rattle-clatter like dishes as the orphans race

into their den. It holds still. Nothing. Waiting. Nothing. And, then in one blink, a thousand stars. I like the noise. I hate the nothing. I hate the waiting. I curve my body around the jar's shape, no longer glass cool to my touch. In that embrace I sleep.

I go days without seeing my children, after the fireworks split the sky. I think they must be stealing corn. I rouse the strength to search for my remaining chicken. I decide to cook an egg the way my father cooked them for me as a child. My toenails scuff the ground. The chicken left no tracks in the dust.

There is a raspberry bush my father had loved. I had hoped to find her there. The patch is brambles and spines more than waving leaves. I close my eyes to see the burgundy of berries. But then red catches my interest. Was the flavor more alive than my memory? I stumble into a run, but arrive no faster than a walk. The red is tangy without sugar. It is juice, but more animal than fruit. It is blood.

I don't follow the marked series of leaves. I relinquish my search for the chicken. I drag my feet back to our tree. The only other sign of life as company is the thread, less elegant than the spider's, dangling from the hem of my skirt. My fingertips are ripped from thorns where I tested the smear on the leaves. Pieces of my skin bleed like petals cut on glass and so I know hearts too can break.

That night, inexplicably, it pours. Remembering the raccoons, I think this must be their playful kiss. The lightning is an entire pack of matches each time it sparks. "The universe forgave us," I state more in desire than fact. Between the powder explosions, I catch scraping nails and clattering bark. With evidence of the raccoons' return, I mourn the chicken. What else could nature steal from the universe's cupboard like the crime I hid from my mother? I laugh at the memory of my father stealing seeds from the peddler's packets. My belly bellows like thunder when before it had merely cackled from spite. The night is filled with the spattering of gunshots. I would worry for the orphans, but I remind myself of their smoky, protected den. I remind myself the storm disrupts the silence, not my neighbors. I tell myself that the universe owes me at least one family to replace the one it stole.

After my father died, I told my mother I would be careful to not spill water or skin the bark from our tree. I would listen to the Fighter so that he did not have to shout so loud. In acceptance his voice might find a softness. I would follow the guidance of the Steward without wondering why it seemed silly or twisted. She responded only in the clattering chatter of crystal. Somewhere outside, I hear fragile smoothness, CRACK.

In the morning, I snap awake to the realization that sometime in the night all chatter had stopped. Window panes and oak planks survived until the morning. Out the screen door, across the earth, I see no cracks. I round the corner to see an aged branch. My breath smolders. Its life burns. The coal-black eyes that at last meet my reflection are already cooled and crumbled into ash.

"We are defined by the end we choose," my father had said. "There is always a chance to make best that which happens last."

Nature or the universe, I do not choose which to blame. Instead, I choose to not disrupt their bodies. I want their future memory cut into bone. I step quickly to the porch. I do not look back. I climb the stairs with the empty laundry basket, move aside the cloth spread over my mother's bed. Its frame sustained my father, his thick folds of thinness, in which only I saw more than less. I peel open the crack in the floor. I press my palm upon the first jar. The back of my hand senses the second. My fingers trip to the right, then the left, counting jars filled with seeds that count. A rainbow. The jars clink but do not cry out. Rain is not winter, but my family had not waited. I sow flower seeds over my mother's damp grave. The racoons had not reached a year, but they had not waited. I tuck the photograph into the char of the snapped tree stump. I shift the weight of my bags. Five jars, not five seeds, stolen. I step out onto the road. I could leave. I turn into the corn. Or, I could do something else. I am not done searching for my father's story, but I am done waiting. ❧

ELIZABETH DODD

Boson Particles, Light Snow

I have given up trying to count
all the snow geese. The world slides

past my skin however it will.
Juncos move through the dull grass

cloaked like the solstice in black
and pale gray.

Last week I walked to the hill's crest,
lay myself down in the solar wind.

Maybe there's only one
principal story, telling itself at the speed of light.

And then, and then, and then, and then—

Let this wildness be enough, a few flakes adrift
in the full field of sight.

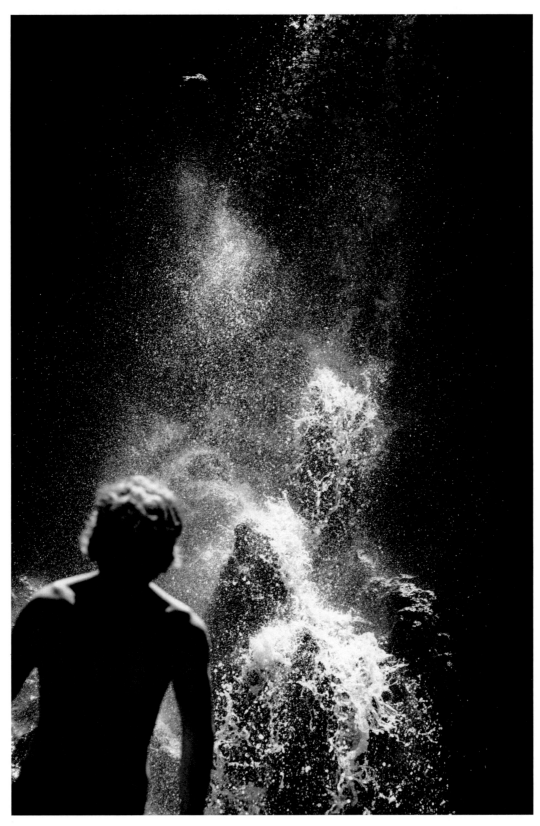

Waterfall | Sarah Platenius
Digital photography, 2017

Day 12 | NONFICTION

I INCLUDED A PICTURE of murky water in the album I created following our family's cross-country road trip several years ago. It's a terrible picture, washed out by overexposure, blurred by movement, and lacking any definition. Because I took the picture and remember that day so vividly, because I have context and perspective, I know that the flat rock in the image is large enough to be shared by three people, toes curled over its edge, testing the water. And that the debris on that rock is sticks, snapped by a thirteen-year-old girl who stood there contemplating her method for submersion.

Rippled lines and small bubbles reveal a current in the water, but I also remember its sound, a gently persistent flow, parted by the supports of the run-down, cracked, concrete bridge I stood on. I can summon the oppressive heat, the chirping of crickets, the olfactory stew of gasoline, dirt, and grass, and then a faraway whiff of sweetness. Below the choppy surface, through the silty churning, I can just make out the patterning of the river bottom, covered in rounded rocks and mud, the water, the boulder, and the river bottom all the same drab hue.

I chose to place the blurry picture in the album quite intentionally, perhaps more representative of what happened that day than any of the sharper, more aesthetically pleasing photographs around it. Within that agitated water, the few darker lines might be *something*. In those ambiguous details, the picture holds possibilities, contains stories that await their telling.

WHERE WERE WE when we saw the snakes in the river? I think I'm gonna write about it.

It's a text from Nicholas, my seventeen-year-old son, settling into his homework in his room upstairs. With each assignment for his essay writing class, I watch him travel through his young life—the big and small events, funny and difficult moments, snapshots of a place or time—and pull something from the swirl. He's learning to choose a worthy story, to tell it meaningfully, to wrestle with the nuances of truth and self-exposure. Constructing a personal narrative, and

the self-reflection and awareness it reveals, is a new, transforming capacity of this age; he constructs his own telling of who he is. It's a class I wish I had taken when I was his age. Frankly, it's a class I wish I could take now.

That's funny, I started an essay about that day a few years ago, I text back, trying to remember the essay's working title.

I push the pot off the burner and walk to my office. Pulling down a photo album, I run my fingertips over the four-years-younger faces and limbs of our three children hiking, as they always seem to do, from oldest to youngest: Nicholas, Julia, and then Elliott. My husband, Jonathan, follows behind.

I flip to the several pages devoted to a little place somewhere along a straightish line between Mammoth Cave in Kentucky and the Grand Canyon. It is easy to find because a colorful pamphlet entitled *Snakes of Missouri* and a sarcastic postcard we mailed home to ourselves are tucked there. The postcard's image is of a stunning river gorge filled with swimming vacationers. On the back, Elliott has written the simple message, *We did not swim here,* with a doodle of himself looking irritable, steam rising from his spiky hair.

My photos show our children looking down into an obviously rushing river, white foam against the large rocks, their faces just as sweaty, pink, and cranky as in Elliott's sketch. They give me the stink eye while eating lunch at a picnic table. This section of the album also includes several pictures of signage reflecting the theme of how not to die idiotically in nature. My best specimen is the metal sign below a flash flood siren depicting an anxious human stick figure retreating to higher ground, chased by a line of rising water. Below that, a laminated paper sign hangs from zip ties: *no swimming today, due to high waters.*

There follow several pictures—*artsy,* my children would call them while rolling their eyes—of old farmhouses and barns, rusted tin roof lines showing generations of additions, wildflowers growing taller than sagging porches, hay bales awaiting pickup in rolling fields. And then, a picture of a wooden sign, *Hasty*

Cemetery, a decrepit concrete slab bridge visible just beyond it. Next, our children explore a shallow stream bed, skipping rocks, running through tall grasses, arms and legs fully extended, then crouching on rocks midstream, their expressions joyfully animated.

And finally, the murky water, the last image of this series. I turn on the desk lamp and, as I do every time I look at it, lean in to see if there is anything discernible within the monochromatic swirl. My phone pings again.

I remember the snake lady.

I turn the page and there she is. A ranger squints under a picnic structure's harsh fluorescent lights, a row of covered plastic pails between her and the night's darkness beyond.

Nicholas, gathering details, asks, *What state was it in?*

I reach for the road trip journals beside the photo album and look at the decorated covers, our children's writing, like their faces, four years younger. *Missery,* I type back, manually overriding my phone's attempt to autocorrect my joke.

"ARE YOU SAYING we haaaave to use these?" thirteen-year-old Nicholas asks, eyeing the three new journals I purchased for their car activity bags, extending the word *have* to a full three seconds, assessing my level of commitment.

A United States map hangs on the wall behind me, with a lumpy route originating from our home in Portland, Maine, destinations bedazzled with sparkly craft materials left over from when the kids were younger—a purple butterfly over Shenandoah, a silver jewel over the Grand Canyon, a horned glittery something on Yellowstone. I am trying to make tangible the vastness across which Jonathan and I will be driving our minivan, every cubic inch of it stuffed with our bodies and the gear we think necessary, with just enough space left to see the six thousand miles of our cross-country road trip out our windows.

Our children have grown up in pants with ripped knees and leaves in their hair, and they know the smell of mud and dew. Their attachment to each other is inextricably linked to the natural places where they have played and grown together. Attempting to guide them toward a deep love of the earth and desire to protect it, I want them to now explore the wild and protected places of their drivable world.

We have waited until everyone can read independently during long driving days, can avoid gross things in public bathrooms, and will hopefully remember this intense whole-family experience. But so quickly *when they can* became *while we still can,* our family still whole for now, but our children's summers with us disappearing in the same order they hike. I sense the shifting and sometimes rough terrain already. Dynamics, growth, and change feel unsettling, requiring adjustments between each other, and sometimes this growth feels a bit like loss. In this trip, I see an opportunity for us to look out at the unknown landscapes before us, to develop the story of who we are to each other now and inform who we will become, with the natural world still a leading character in this shared narrative.

The kids fill their blank journal pages with their own projections, their own versions of *this family adventure.* Elliott, a possible future artist, covers his pages with drawings of wildlife and their landscapes, colored with pencils from his activity bag. Julia, a possible future author of cheerful self-help books, writes long exuberant descriptive narratives. And Nicholas, a possible future curmudgeon/financier, experimenting with *a tone,* scribbles comic strips about the misadventures and mishaps of an imprisoned family, his landscape often, ironically, limited to the small and increasingly stinky minivan.

In each entry, his thirteen-year-old capacity for both self-awareness and self-consciousness, his developmental struggle for agency and autonomy, is projected onto the page with insight, sarcasm, truth, and wit, only intensified by my competing desire for togetherness. In his doodles, I lie in a sweaty exhausted heap while my children prance up the trail in the Grand Tetons. I anxiously chase them with a leash near a ledge in the Grand Canyon. And as *their captor,* I am struck by lightning after *forcing* a hike under darkening skies in the Badlands.

Nicholas spends more time on his journal's title page than any other: *Death By Road Trip. A story of pain, suffering, and missery.* He decorates the title with a skull and crossbones dripping green reptilian blood. Several pages of doodles in, he writes:

Day 12
We are in Missouri and we were going to go swimming in a river, but it was flooded so we couldn't.

Then we were going to go swimming in another creek

and we had been splashing around when we saw 2 large black snakes in the water. We freaked and ran.

Then we got ice cream and went to a weird snake talk and a guy let a stick bug crawl on his face, but other than that it was a normal day.

P.S. The snakes We found out Weren't poisonous

Somewhere down a long dusty Missouri road, without interpretable signage or a ranger's protective care, grappling with our own competing needs, and all of us very, very hot, we stand beside a creek. We are assessing the creek's potential to offer relief from tension, heat, and worry, hoping for a moment of memorable family joy. I am desperate to prove that this trip, the arduous miles, the minivan's slow destruction, are worth it. We swim with snakes.

The *story of pain*, first described by an ornery thirteen-year-old, will get told quite differently four years later by that same boy. With a changed perspective and new capacities, he tells it for a new audience in his "Snakes" essay for his high school writing class. My own essay, written a few years back, entitled "Erratic," tells it slant, a narrative constructed by another, someone who was there, but looking through a different lens. He and I experience, interpret, and attribute meaning independently of each other, as is, increasingly, our way; both true, but each holding truths that are our own.

OUR TUMULTUOUS family bonding treks create inside family jokes and some of my most uncomfortable, yet fondest, memories. I know our mishaps are actually what makes them valuable. This does not mean I am any less embarrassed by our family's circus caravan.

Elliott is reading *Garfield* comics to us and we are all laughing, hard. Elliott at the portly feline humor, the rest of us at his infectious giggles and the between-us amusement that comics you can't see just aren't that funny. We are all a bit giddy, several rather disastrous days behind us.

We have spent the past week jammed together into the family minivan, released only occasionally into open spaces on our desperate drive cross-country.

It's hot outside the minivan, over 100 degrees, and a series of severe thunderstorms have been our traveling companions. In Pennsylvania, we dashed through green-hued air to take cover during a tornado warning. We did not swim in the West Virginia lake closed for high bacteria counts. In rural Kentucky, the high river water tugged at groaning guidelines as a tiny ferry labored to inch our minivan across.

We are in Missouri, the heat is unbearable, the waters are high, an underlying cantankerous mood on the verge of surfacing. All I want is a good swim.

The photogenic swimming hole I had steered us toward was closed due to dangerously high water. Seeking shade and a new plan in an open field, we stop beside an enormous boulder, bigger than our minivan, *an erratic*, I think to myself. I am familiar with large boulders precariously dangling from mountainside cliffs, jaggedly rising out of lakes, geologically out of place, brought to our Maine landscapes by ancient glacial movement. This boulder, a sign tells us, was brought here by water, not ice, and just three years ago during a flash flood.

Our difficulty finding a place to swim is as disorienting as the miles and the changing landscape between us and Maine, where temperatures are lower and swimmable water easier to find. Trying to avoid a heat-induced all-family meltdown, we eat lunch in a shaded picnic area. I pull out my camera and hide behind it, while I worry about whether this trip is working, my growing but currently wilting children, climate change, severe weather, and the unpredictability of nature and family dynamics. Elliott chases lizards through some bushes.

At the visitor center, we ask when the river might open again, hoping that if a flood can come on in a flash, then so might a draining.

My mom finds rangers to be embarrassingly fascinating, and this one recommends we visit another spot. "Y'all will know you have gone far enough when you pass Hasty Cemetery." Great little detail, Mrs. Ranger, really reassuring.

I silently enjoy a young ranger's use of the word *creek,* the word and pronunciation not Maine-speak, as she directs us to a place *where the local teenagers swim.* The word, the place, sound perfect, a road trip *find.*

It is the communal anticipation of this place, more than Elliott's reading of partial information about the antics of a cat, that has this minivan in hysterics.

Damp with perspiration, we drive for an intolerable amount of time.

We get lost three times, which I try to hide with stops for pictures of farmsteads, gorgeously sweltering in the sun.

Finally, we park by said cemetery; despite its hasty nature, there is no sign of exposed limbs, thank goodness.

I snap a picture of the *Hasty Cemetery* sign marking a small assortment of headstones tipping left and right, already imagining the scrapbook pages this afternoon will create, seeing humor in the role of signage today.

Overheated, irritable, we cascade out of the van like the water we so desperately seek, into the intoxicating humidity.

I climb onto the bridge where I listen to the hot breeze above and the trickling water below. Elliott splashes in the shallow waters, leaping to a small island, rustling through its long grasses, and then grasping a small pebble and throwing it as far as he can. Jonathan, Nicholas, and Julia scramble over large rocks to the deeper water, their tight voices and moods easing. Julia tosses sticks into the current and watches them float downstream, down-*crick*.

Having unearthed a quiet sanctuary from the oppressive heat, we all are quickly in much better moods.

This is why we are here, I think to myself.

The bottom of the creek is rocky, and boulders protrude from the water, allowing us to pick our way along them to the middle. I venture the farthest, tottering precariously on a sharp-edged rock.

As they weigh a gradual entry against a sudden plunge, dancing to cool their feet on the sun-baked rocks, each of us sees movement, and we stare silently at something we have never seen before.

From the bank's thick undergrowth appear two quickly moving embodiments of an uncontrollable situation. Initially unidentifiable, visible first only as two ropes, dark and silent, incomprehensibly agile, they elicit paralyzing fear.

This is where we die, I think, as bliss becomes fear, these sinuous lines materializing into snakes.

Stumbling backward yet somehow keeping my footing, I execute the quickest route back to the bank in a rare instance of coordinated athleticism.

I feel Elliott beside me, his hand suddenly in mine, and hear Nicholas splashing, scrambling, and screeching "Snakes!" I am unmoving and silent, processing what is happening, my eyes on the water, and on Jonathan and Julia, still down in the creek.

Their bodies slither muscularly, their heads above water, moving in a definite path toward Julia and my dad. The two of them clumsily entangle mid-leap in mid-air, falling with a huge splash, my mom's gasp beside me louder still.

I strain to find the snakes in the churning water and see they have stopped their forward movement, and then sinuously turn and move slowly back to the shadows.

Startled, the two snakes turn their ominous heads away. Julia and my dad half-swim, half-run the gap to the bank.

Elliott and Nicholas take off running to meet them at the end of the bridge and they sprint, in a chaotic tangle, grabbing at each other, eyes wide, yelling nonsense, away from me. I am left alone on the bridge to watch the snake's serpentine ride of the current until they are out of sight, and gone.

Sopping wet, we collapse in the cemetery grass, no longer worried about semi-exposed corpses. After spurting, gasping yelps, we all break into terrified laughter, our adrenaline and emotion expressed in a high-pitched frenetic family cackle.

We do what Mainers do when times are tough and above fifty degrees. We go for ice cream.

That night, we attend our campground's ranger talk, a thunderstorm approaching, not knowing the topic until we arrive: *Snakes of Missouri.* "What strange timing," I snort, eyeing the five covered pails and the picnic pavilion's metal roof. "Better here than in our tent," I decide, as thunder crashes and hail pings off the roof.

What a strange place, I think. There are no danger-ous snakes back home, only harmless garter snakes startled often by my children's bare running feet. *What a strange day,* I think, waiting for the presentation to begin, a stick bug traversing a father's face, his instinct to flick and gasp better controlled than my own.

I focus on the frizzy gray hair and reflective glasses of the ranger whose snake is nonconsensually in my usu-ally snake-free bubble, wrapped menacingly around her arm. Since my sphere of anguine safety has already been violated today, I brush my fingers across the scaly skin, feeling the strength below. How could this strange woman and I have such varied ideas about the same creature?

The ranger tells us about removing a large cotton-mouth from the visitor center's picnic area earlier that day. "What time was that?" Jonathan asks, feigning dis-interest. "Around lunch," she answers.

We learn how to identify Missouri's native snakes, their preferred habitats and behaviors, and that though there are very few poisonous snakes, their toxins in-gested if eaten, the tall grasses and brush of Missou-ri seem to be slithering with venomous snakes, their deadly toxins injected by their fangs. I am processing our unseen cottonmouth picnic companion and the copperhead habitat where Elliott has been thrashing about for days when Nicholas interrupts my thoughts.

I blurt out, "We saw two snakes in a river. Their heads stuck out of the water." She caresses the beast she is hold-ing, the one I pet minutes before. "That means they weren't venomous. If they were, their whole bodies would float on the surface. Like this guy, he's chock-full of the stuff."

My eyes on that snake, I reach out and grasp Julia and Elliott's shoulders a bit too hard. "Did you hear that? They weren't poisonous!" We didn't even almost die.

"Venomous," they correct me, looking white around the eyes.

"Venomous," I correct my falsely cheerful mother. I set-tle into a state of sarcastic amusement. "This is exactly the kind of day I was afraid we would have on this road trip," I snicker with my mom, dashing through a down-pour to our campsite, located beside the campground's scenic pit toilet.

FLIPPING THROUGH Julia's journal from the road trip, I find her entry from Day 12: "We were all a little scarred." Was it a spelling mistake or intentional profundity?

I've always wondered if we ruined nature for our children. If the bug bites and scrapes, the chaotic re-treats down mountain trails as lightning flashed, the frantic singing in bear-filled woods, the swimming in snake-infested waters may have caused more fear than ease.

"So. Anguine." I say to Nicholas, raising an eyebrow, having just finished reading his essay.

He smirks. "I looked that one up."

"I needed to look it up, too," I admit. "It's a good word."

Anguine: of, related to, or suggestive of a snake. Not just another word for a snake, this word speaks to the perceptual experience of an initial ambiguity, the movement from nothing, to perceived, to being. From ripples in water, to snakelike, to snake. An evocative moment, when looking into murky water or out at the next unknown, searching for something true about yourself. When we experience the first pricklings of awe, change, loss, or fear. When we realize we have no control, should have no control, in a place, over a be-ing, over the meaning they create. When we draw upon a richly textured landscape full of shadows, patterns, memory, and disruptions to what we thought we knew. Moving from unknown to known, from lost to aware, from fear to strength, from uncertainty to purpose. Only then can we begin the process of growth, of de-fining, or redefining, ourselves.

Soon after I read Nicholas's essay, I am standing beside him, gazing out at a familiar vast woods and line of mountains beyond. When our tour guide asks him what he thinks he might study in college, I am surprised by his answer. I whisper with him as we walk across a campus where so much of myself was defined, of which so much, these many years later, is being redefined but still pulled from the same swirl of truths. "So, environmental science?"

He smiles sideways. "Yeah, well, I had to come up with something. I really have no idea. But Earth has a lot of problems that someone needs to help. It might as well be me."

Sometimes it takes a couple of snakes in the river to jolt things, vividly, into perspective. ❖

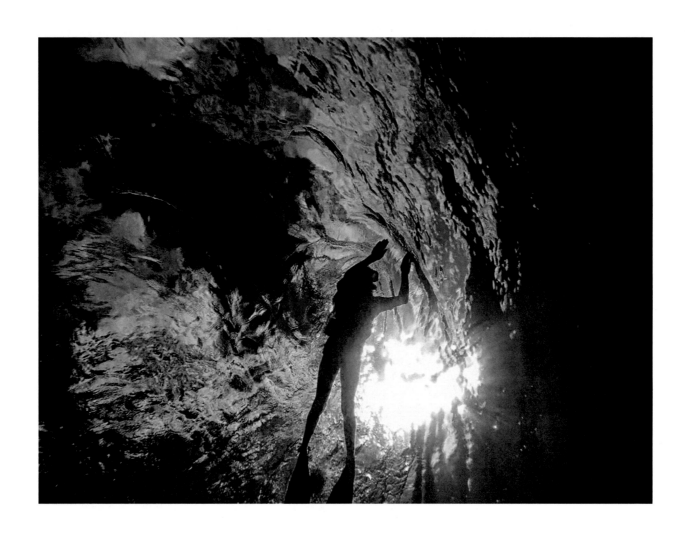

Water Bug | SARAH PLATENIUS
Digital photography, 2017

JANINE DEBAISE

The Space Between | NONFICTION

We raised our kids in the wrack zone. Or at least, in the summertime we did. My sister Carroll and I set up lawn chairs near the cattails and decaying seaweed and the old gray dock, knowing that if we kept an eye on the waterfront, none of our kids would drown. We knew well the marshy edge of my parents' camp—we'd spent our childhoods there. But now, with seven kids between us, Carroll and I were the adults. It's true that our adult behavior mostly consisted of reading trashy magazines, making snarky comments about celebrities, and joking about whether it was too early to drink the first beer of the day. But still, we had crossed over from one stage to the next. We were the parents sitting in the sun, not the children screaming over a dead carp that had washed up.

The wrack zone, the land just below the high-water line, is an intimate and changeable space. On the St. Lawrence River, the water is highest in early spring, and we pile rocks on the dock to keep it from floating away. By July, the spongy, muddy area is dry enough to spread out a blanket for small children. It's a lovely place for sunbathing, if you don't mind the occasional spray of muddy water from a dog who ends his swim with a vigorous shake. Our kids picked cattail punks, squealed at the water snakes, and chased little frogs that they never actually caught. When the kids got overtired and whiny, Carroll pulled out her party trick: she climbed into the old metal rowboat, disappeared down the creek, and returned with a turtle. All the kids came running then, each begging for a turn to hold the creature before its release back into the marsh. Catching turtles was Carroll's special talent, and no one knew how she did it.

Our family camp is a peninsula of oak trees tucked into a huge marsh on a shallow bay. When we want to swim in the deep clear water of the river, we take a boat out to an island. Whiskey Island is the best for gathering driftwood, Flat Rock is close for an evening swim, and

Artillery Island has natural indentations that make warm pools for small children. This part of the river is called the Thousand Islands, but that's not an exact count. There are 1,874 islands and so many rocks and shoals that boating accidents are as common as scraped knees on a school playground.

My siblings and I learned to swim at Third Brother's Island, where two big rocks stand only a few feet from each other. My mother yelled encouragement as we flailed our arms and leaped from one rock to the other. I still remember the horror when my siblings and I arrived one sunny day to find the names "Bob and Madeline" spray-painted on the island in huge black letters. We spent hours scraping at the paint, determined to erase that act of vandalism. It was years before their names disappeared altogether. My mother used to remark that if ever a couple approached us and introduced themselves as "Bob and Madeline," they'd likely find themselves attacked by a gang of angry children.

We never set foot on Ironsides Island, a narrow chunk of rock with tall cliffs and white pine trees. It's a rookery for great blue herons, who have big untidy nests balanced precariously in high branches. Every spring my father and I would glide by quietly in his wooden sailboat to catch glimpses of the baby herons, long-legged and awkward.

The marsh that stretches out from my parents' dock is protected by the New York State Freshwater Wetlands Act of 1975. But legislation, it turns out, can't protect you from everything.

The oil spill happened during the summer of 1976. I was fifteen years old. We heard the news on our car radio, but when we pulled into camp, everything looked the same. My father went off in an aluminum boat to see what he could find out. He returned quickly. "I couldn't get out to the river," he said. "They've boomed off the bay."

It was a smart move. Goose Bay is about two miles

long, but the opening to the river is just a few hundred yards. Floating booms helped prevent the oil from reaching the ecologically valuable marshes. We listened to the car radio and drove to town for a newspaper. The oil leaked for more than a day, three hundred thousand gallons in all. "The worst inland oil spill in North American history," the Canadian announcer said.

It wasn't until the booms were removed and we went out to the islands to swim that we saw the oil. It was what they call No. 6 oil, and it looked like tar. Thick, black tar, like something you'd pave a driveway with.

The oil spill happened when the water was at the highest point it had been in years. When the water level dropped, thick bands of oil remained, suffocating every rock, every island. The wrack zone still held weeds and driftwood and dead fish, but now they were embedded in big swathes of black tar, several inches deep and several feet wide.

We tried to go for a swim at our favorite island. My father brought the boat alongside the shallow rock shelf, and we stepped out. Then we had to scramble across the rock and jump over those thick piles of black oil. We spread our towels on a high rock and then came back down to jump over the oil again and take a swim. We tried to be careful. We *were* careful. But still, when we got back to camp that evening, I found black tar on my shorts, another spot on my bathing suit. Nothing would wash it out. Eventually, my mother put the clothes that had been touched by oil into a trash bag.

There was a clean-up operation, about $8 million worth. But mostly, that money went to cleaning up oil on the mainland and the bigger islands with summer houses. No one cleaned the little islands where we went swimming or where the wildlife nested. Ironsides Island lost one third of their adult great blue herons that year.

The oil degraded over time, getting less and less gooey, but the color remained. Mostly, we just got used to it being there. I remember once, more than a decade later, when my father and I took my uncle for a sail. My uncle asked, "Why do all the rocks and islands have that black stripe around them?"

My father said, "That's the high-water mark from 1976. The year of the oil spill."

I felt startled. I'd gotten so used to the black stripe that I didn't even see it. I think that's what happens with environmental problems. Climate change has brought us warmer summers, stronger hurricanes, flooding along the coasts. We accept it as the new normal. Air pollution and toxins in our food have brought us soaring rates of cancer. The incidence of breast cancer in American women has more than doubled since the 1960s. We see these statistics so often that we accept them as inevitable.

By the time my own kids were old enough to swim off an island, decades of weather had degraded the oil but there were new problems, like zebra mussels, an invasive species that soon grew out of control. We bought the kids water shoes to protect their feet from the sharp zebra mussel shells, and that seemed an easy fix, although I felt sad to think that my kids wouldn't know what it was like to swim with bare feet.

Wassail Island became our favorite. It was close enough to reach by canoe or sailboat, which meant that our ragtag flotilla could get there easily. Although it was small, there was something for everyone: a long shelf of rock that stretched under water so that my brother-in-law Jimmy could lie in the shallows, a sloping rock where we could spread our towels, and a high rock where the teenagers could leap into the river. But my mother was often the first one in the water. She'd dive in, then surface to do the backstroke and call out, "It's refreshing!" We all knew that the word *refreshing* really meant, "Oh God, this is cold."

The sun beat down on the gray rock. My mother and my sister Laurie, both redheads, brought their towels to the mossy spot under the two pine trees and sat quietly in the shade, careful not to disturb the ospreys nesting above. My father, using a life jacket as a pillow, took a nap in a rock crevice. Carroll, who still had the blonde hair of her teenage years, preferred to sit in the sun, her tanned face turned toward the warmth. She didn't like cold water, but the year my youngest son was learning to swim, she got into the river to show him how to float his body, hang onto a rock, and kick like crazy. As I lay on the warm rock, I could hear them splashing and laughing. Carroll was close to my four kids; she babysat them every weekday in the winter. Her kids and mine played a new game called Shoal Walk, which took them from rock to underwater rock, all the way out to a little island.

•

Carroll's three daughters and my four children grew older. My sister Laurie and my brother Kevin added kids to the family. My parents had ten grandchildren who grew up and went to college and graduate school, but every summer we gathered at camp.

Then came the July vacation of 2014. We didn't realize it, but this was the last time we'd ever be all together at the camp—my parents and their five children.

My kids and my nieces and nephews set up tents under the pine trees. For meals, we crammed in close around two long picnic tables pushed together near the fire pit. After each meal, I used a deck of playing cards to randomly select which two family members would wash the dishes, a task everyone hated because it's almost impossible to clean greasy bowls when all you've got is a single basin of water heated on an outdoor grill.

Carroll's oldest daughter had given birth that May, the first of my parents' great-grandchildren. Carroll was so excited to be a grandmother that the rest of us barely got a turn holding little Riley. My children were still close to Carroll, even though they'd long since outgrown the need for a babysitter. In the manner of young men everywhere, my sons showed their affection by teasing her. If she left her lawn chair to go to the outhouse, they'd take it and put it high up in a tree, over her head. They'd yell her name, "Carrrroolllll," drawing it out, then pause for effect before shouting, "SUCKS!" Her laughter encouraged this behavior.

Change was coming to the family. My father, in his eighties, had given up his wooden sailboat, which he'd designed and built himself, but was now too much for him to handle. Change was coming to the islands too. *NO TRESPASS* signs sprouted on Wassail Island. Someone had bought it; soon a camp and dock would follow. Never again would we sit on that sun-hot rock or jump off the cliff into the icy water. It seemed only a matter of time before every rock and island would be owned, developed, and built upon.

But still, we were at camp, and we were together, on the same river where my father had come fishing with his father in the 1930s, where my parents had come as newlyweds in the 1950s. My niece Jaime dangled her baby Riley above the river to dip her toes in for the first time. Like all the family members who had come before, Riley cried as her feet hit that cold water. My niece Erin glanced at my mother and said, in perfect imitation, "It's refreshing."

•

Late that afternoon, my youngest sister Colleen announced that she and her husband Frank were going to cook supper for everyone. They drove to town to buy sweet corn picked that morning, packages of chicken, and bags of new potatoes, which they would boil in salt water. Colleen and Frank are both gourmet cooks, so we knew the feast would be delicious. We knew also that it would take *forever* to cook. My father kept wandering over to the grill and giving broad hints about how close the sun was to the horizon. But you can't rush a foodie. It was dusk before the meal was ready to eat.

"Don't we have candles?" Colleen asked, as if we were eating at a lovely dining room table and not a couple of old picnic tables.

My mother disappeared into the cabin and returned with a dusty box labeled "Emergency candles."

"Is this an emergency?" I asked.

"Of course it is," Carroll said and grabbed the box.

We had no crystal candle holders. But Carroll lit a candle, dripped wax directly onto the picnic table, and then stuck the candle to the table. "I'm going to use the whole box," she said recklessly.

My father sat at the head of the table, in a lawn chair that he had reserved for himself by tying on a piece of fluorescent orange surveyor's tape. My mother sat next to him, and the rest of us crowded onto the benches: my four siblings with their spouses and children, my husband and children, twenty-five people in all. In order to make room for everyone, we made the left-handed people sit together.

The food was delicious, particularly the fresh corn-on-the-cob from the grill. The little candles cast a soft glow onto sunburned faces. We ate and talked and slapped at mosquitoes.

Eventually we moved from the picnic tables to the campfire, everyone jostling to get a spot, and we played the Music Game. I held an old book that someone left at camp years ago—a hardcover copy of *The Long Winter* by Laura Ingalls Wilder—and put my finger down on a page to choose a word at random. Then the family had to sing as many songs as they could with that word in it. My brother, Kevin, kept up a running commentary on how our team was doing, commentary that was essential because we were competing with imaginary teams.

"Brazil just got seven points for the word FROG," he said. "That's going to be tough to beat." He was interrupted by my husband, Bill, launching into "Joy to the World" by Three Dog Night.

The Long Winter was a terrible book for the game, since I kept getting words like "trousers" or "newfangled." But when I tried to switch books, all the young people protested.

"It's a TRADITION," my son Sean said. "We have to use that book."

My parents sang the "Chattanooga Choo Choo" and "On the Good Ship Lollipop." Carroll's three daughters sang "The Wheels on the Bus," their blonde hair swishing as they did the hand gestures. We sang Christmas carols and church hymns and songs from television commercials, the theme song from *Friends,* songs from *The Sound of Music,* and lots of old show tunes. My introverted youngest son, Bryan, prompted by his aunts, sang the score from *Les Mis.* I think that was when we surged past Bolivia and Peru in our standings.

Above the oak branches, we could see stars. "I'm making blueberry pancakes for breakfast," my mother promised before she retreated with my father to their cabin, where they could listen to the singing from their bed. Carroll slipped away quietly without saying goodnight, as was her habit. The circle around the fire kept getting smaller, until finally even the young people were ready for bed. I watched the glow of their smart phones as they moved from outhouse to car trunks to tents, and I poured a bucket of water onto the coals. Smoke rose into the night sky.

Just a few weeks after we returned from camp, Carroll was diagnosed with breast cancer. We moved suddenly, all of us, from those carefree sunny days into a dark space that included chemo treatments and hospital rooms and crying in the car on the way to work, that space between life and death, where the wrack you collect are memories that you will hang onto like smooth pieces of driftwood.

Four months after that candlelit meal under the old oak trees, Carroll took her last breath. She was fifty-five years old.

Four months was not enough to prepare me for the enormity of that loss. The day after Carroll died, I posted a photo on Facebook to let everyone know this jarring turn my life had taken, because I needed everyone to know that they would need to approach me gently, like you should approach someone who has just survived the most difficult shock.

I felt caught in a wrack zone, that space between a lifetime in which my oldest sister was alive—to walk me to kindergarten on the first day of school, to stand with me at high school dances, to help raise my children, to sit with me in the sun—and the rest of my life, which I would need to live without her. I sat with my laptop and looked through photos of Carroll. So many of them were taken at camp, with her surrounded by her kids and my kids. In the photo I finally chose, Carroll is sitting on the rock of Wassail Island, her legs stretched out to touch the water. She's laughing at my sons, who are teasing her about something. Her face is turned toward the sun, toward the light.

What causes breast cancer? Here is what we know.

In the 1960s, a woman's lifetime risk for breast cancer was 1 in 20. Today it is 1 in 8. More than 80 percent of women diagnosed with breast cancer are the first in their family to develop the disease, which suggests that breast cancer is caused by something more than genetics. We know that industrialized countries have higher rates of breast cancer than non-industrialized countries.

Estrogen is a hormone that is closely linked to the development of breast cancer. Xenoestrogens, synthetic chemicals that act like estrogen in our bodies, can be found in weed killers, pesticides, plastic additives, and spray paints. They are found in polyvinyl chloride (PVC), which is used in the manufacture of everything from food packaging to shower curtains. And we know that 100 percent of the air in the Lower 48 is contaminated by carcinogens.

When we talk about environmental problems, it's easy to focus on the dramatic and immediate, like an oil spill that spreads black tar across the islands we love, that smears sticky black stuff onto the wings of birds, that kills wildlife and makes it hard for local people to make a living. The 1976 oil spill left indelible images on my fifteen-year-old brain. But we tend to ignore the more subtle and terrifying environmental problems,

like benzene in vehicle exhaust or pesticide residue in the food we eat. We've grown used to breathing polluted air, to being exposed to carcinogens on a daily basis.

We are good at denial. We discuss environmental issues as if they affect only the bald eagle or the great blue heron. Perhaps it's just difficult to admit to ourselves, as a species, that we are hurting not only plants and animals all over the world, but also the people we love—our sisters and brothers, our parents, our children, our grandchildren, ourselves.

I still sit in the wrack zone at camp, keeping an eye on my grandnieces and grandnephew as they toddle and crawl in the grass near the dock. I think about how much Carroll would have loved her role as grandmother to these curious, lively children. I don't catch turtles: that secret died with my sister, although I suspect that it had something to do with her patience, her willingness to sit quietly in an old rowboat for long minutes, staring into the cattails, the hot sun beating onto her bare shoulders, waiting for a tiny creature to come to her before she took it carefully into her hands. I don't have that kind of patience. But I let Carroll's grandchildren clamber into the canoes and trail their hands in the marsh water, and I tell them stories about pirates and sailing ships.

During the long winter months, when I read articles about environmental toxins or attend a lecture on air pollution, my thoughts return to our family camp— that beautiful and scarred landscape with oak trees damaged by invasive gypsy moth caterpillars, rocks that wear a black stripe from that long-ago oil spill, bald eagles who have made a comeback after DDT was banned, osprey nests contaminated with bits of plastic, and down by the dock, in that space between land and river, a second lawn chair that will remain forever empty. ❖

For the Young

I was not like my sister.
She could not spear a worm, slide it
onto a hook.

One July day
in the Rockies—cloudless,
mosquitoes oozing

over lake, dark envelope
of woods
a breath away—

I tightened
the line between me
and the copper glean nicking

the surface,
late afternoon. My father
pulled out his bone knife to say

come with me. I followed him
into the woods, loosening the hook
from the rainbow's lip

as I tripped in the shade.
I had never seen him fillet
a fish up close.

Fish relinquished, the scales' shine
stung me silent. Words softened
in his mouth as he held knife tip

to tail fin, traced without cutting skin.
Score swift, like bread.
He lifted the blade and sliced into

flesh. At the opening, we saw
our mistake. Blood came
and went, whispered

red on leaves.
He reached within
the deep cavity, spilled

a purse of small coins—her eggs.
My stomach ballooned.
I pressed lips together while he emptied

the slick body into the stillness.
Later, carrying our catch
he said it wasn't a loss.

The coyotes combing these parts
would thank us
for feeding their young.

EMILY PASKEVICS

Stray Dogs | FICTION

THE WAY MY GRANDMOTHER TOLD IT, we were walking in the woods. I was at an age below language, a toddler, but I could already identify several plants that we gathered along the way. I'd watched Grandma's wildcrafting from my very first days.

Squatting next to a wild raspberry bush, Grandma said she'd noticed that the birds had gone quiet, but assumed that it was because they were sizing us up—reacquainting themselves with our presence in the woods. But then there came the sudden sharp cry of a jay and Grandma leapt up from the raspberries, scanning the surrounding woods with her sharp green eyes.

Meanwhile, I'd dashed ahead, having spotted something bright along the path. I imagine it was a berry, bird, or flower (I say *imagine* because I don't remember this, and only parts of what happened next). I didn't even cry out when a streak of silver, gray, and claws arched out from the rocky ledge above and struck right into me.

Every time she told me this story, my grandmother would describe how the lynx snarled as it held a death grip on my little neck. But all I have is the memory of pain, and the feeling of being unable to breathe from the shock that hadn't yet turned into fear. I don't remember the predator, just the way its claws dug deep as my world flipped over and I was dragged toward the underbrush.

I can also remember my grandmother's voice, rising loud through the surrounding woods. It wasn't a wail or panicked scream, but a deep, resounding roar that formed three words: LET HER GO.

And the lynx did. Grandma said that she also hurled a couple of stones at him, but I didn't see or can't quite remember. My face was still pressed into the earth. As the animal retreated into the bush, my grandmother scooped me up and ran with me in her arms all the way back to the village. I remember peering over her shoulder and seeing spots of blood following us along the trail. It wasn't until later that I realized the blood was my own.

There were deep gashes near my throat that had to be sewn shut, the scars from which I still wear on my skin today. Grandma said that the only time I made a sound through the whole ordeal was as they stitched my neck back together at the hospital, when I let out an ear-splitting scream at last.

A child nearly mauled to death by a wild animal—the story is harrowing, and far from commonplace in the twenty-first century. But this isn't the way that my grandmother told it to anyone else. She never mentioned the lynx. Instead, she blamed my injury on one of the rare stray dogs that lurked around the edges of town. The lynx version was something that we kept secret between us for most of her remaining years.

I was twenty years old when I finally asked her why she told others the story of the stray dog and kept the lynx just for us. It was a winter afternoon, and I was on holiday from university. Grandma was sitting by the window, weaving together strands of red and green cloth. She drew a long breath before replying.

"I saw that lynx," she said. Her voice had grown raspy in recent years. "People would've said he was rabid, but he wasn't. He was just skinny as dried bones, half-starved. If I'd told, they'd have hunted him down and put a bullet through his skull. This is his home. For all I knew, maybe he was the last of his kind around here."

I reached over to help her put a new spool of thread on the spindle. "But he almost killed me."

Grandma paused in her weaving, and her gaze drifted to the window. Snow was falling across her winter-bound garden. Then she turned her green eyes on me.

"When I told him to, he let you go."

When I told my practical mother this story—the *real* story, about the lynx—she laughed outright.

"She's forgetting things, making up legends. There isn't any such thing as lynxes around here. Honey, a stray dog's a stray dog and you're lucky you didn't get some terrible disease—let alone your head bitten off."

As life led me away from the woods, and away from my grandmother, her cabin was the place I thought of when I most longed for escape. I visited when I could. Sometimes she would phone me in the evenings as I worked overtime in my urban cubicle, and I knew that she had gone all the way to town just to use the general store's payphone for the call. She would recount in great detail the animal tracks she had recently followed through the muck or snow: snowshoe hare, black bear, white-tailed deer, coyote. Then she'd drop her voice to a hoarse, secretive whisper: "and *lynx*. When you come, I'll show you."

I humored her, knowing it was our thing—our theme, our story, a thread weaving together the lives of grandmother and granddaughter that I was unwilling to sever. But the tracks would be long gone before I had the chance to visit her, of course, and I'd long since done my research. There are no more lynxes in that part of the country.

In the winter of the year I turned thirty, Grandma died. She'd turned ninety a few months prior. After the small funeral in the village, I went alone to her cabin at the edge of the woods. I walked through the door and breathed her in. Everything was just the same: her loom waited in the corner, lined with colorful cloth that wasn't quite finished. Garlic from her garden hung in bunches from the ceiling above the woodstove. The table was even set—for two, although Grandma had lived alone for well over a decade.

I couldn't linger inside. Grandma's snowshoes were propped up near the door, where she liked to keep them handy. I strapped them to my boots, and after stumbling around for a few minutes I found a steady stride. The rhythm was a relief. I headed across the clearing, toward the familiar trail that led into the woods. It was narrower than I remembered, slowly being reclaimed by wildness after years of minimal use. As Grandma had aged and maintaining the trails had become more difficult, her range was reduced to the little clearing around the cabin—her garden, the well, the outhouse. I steadied my breathing and sidestepped over a tree that had fallen across the way.

As my movements grew sleeker, I started noticing the creaking of branches as they rearranged themselves under the snow. There was a sudden swoop of wings that may have been a startled owl. I caught sight of a northern cardinal and heard the single-note call-and-response of its mate, along with the buzzy exclamations of chickadees. I passed the great oak that Grandma always pointed out when we walked the trails together—it was her favorite tree, with a trunk so vast that the two of us could wrap our arms around it and our fingers still wouldn't meet.

As the trail wound down toward the river, I wondered if I'd be able to hear the water running below the ice. A snowshoe hare bounded out of the shrubbery and we both froze at the unexpected crossing of our paths. Then he bounded along ahead of me, leading the way. I picked up my pace, breathless and already starting to sweat under my coat.

The path ended abruptly at a rock ledge, overlooking the frozen river. The hare hesitated, then hopped down to the bank and across the ice before pausing again. I closed my eyes for a moment, listening for running water. Yes, there it was—faint yet distinct, like the sound of muffled laughter.

As I turned to head back up the trail, there came a snarl from below. I looked back just in time to see a sudden flurry of claws and fur. I made a sound in the back of my throat—a strangled gasp or cry—and then there was nothing but a spot of blood in the snow. I scanned the bank, but the hare and its unseen predator were gone.

How long I stood out there on the rock cliff after that, I couldn't tell you. ❧

Natural Disasters | Htet T. San
Collage: digital photography and illustration, 18 x 12 in., 2014

Various Companions

Along the dirt road, repeating rabbits,
a fingering of rain.
A west wind galvanizes. How again

the wind, the whole point. Each night, a cat hisses
his memorable remarks, couldn't be clearer.

I have been trying to sit beneath
mountains with my common statements

and reasons. Instead texts come forward,
provoke and then vanish. Stay calm,

the therapists say. Even if
the person you love is preoccupied
with something missing.

NIKKI J. KOLB

Jaw Pressure | NONFICTION

MOON'S JAWS wrapped swiftly around the back of my knee. His four canines clamped down, digging into the soft flesh of the joint. I stamped my shovel against frozen ground, shouted and whirled around fast enough to scare him off. I found him standing about ten paces away beneath the shadow of a large pine, where he was staring at me curiously out of chestnut-brown eyes surrounded by soft, sandy fur that gave his face such an innocuous, dog-like quality.

Part wolf, part dog, Moon was silent on the approach. Or maybe I was just preoccupied. Definitely preoccupied, enough so that I had, without much thought, turned my back on him. Just minutes before I had been sitting on a rock with Moon behind me, rubbing his scent onto my head, his canines grazing my skull as his cheeks transformed my hair into knots with pound after pound of his crown on mine. It was only when I began to fill in a hole in the enclosure that he used those teeth against me.

Though I had worked with captive-bred wolves at a wildlife sanctuary for over two years without any incident and was well versed in animal care—I even trained new volunteers to avoid this very circumstance—here I was with three weeks left at the sanctuary, finding myself in a wolf's jaws.

The power of a wolf's bite is measured at 1,500 pounds of bone-crushing pressure per square inch—twice that of a German shepherd's, and strong enough to chew through a moose femur. A human's jaw pressure? Merely 120 pounds per square inch. And though wolves have just ten more teeth than us, those forty-two chompers are likely their most widely recognized, feared, and celebrated feature.

What big teeth you have!

Wolves are natural opportunists. They hunt the young, the old, and the sick, strengthening their prey populations and promoting healthy ecosystems by keeping herds on the move and picking off the weak.

I gave Moon an opportunity.

He was new to our pack. Rescued from an animal hoarder along with his sister and two pups, Moon and his family were taken to a shelter where they were neglected by staff due to fear of the wolf that dwelled in each. That's when they were turned over to us, a refuge in rural New Mexico focused on rescuing wolves and other wild canines from the exotic pet trade, providing lifetime sanctuary, and educating people about the *lobo*. We didn't quite know Moon's personality yet, but he had a reputation for being naughty, sometimes charging female caretakers only to dart past them at the last moment. Testing his bounds.

It was my fault for turning my back. I knew that. I also knew that I was lucky. I still had my leg, and walked backward out of the habitat, shovel in front of me until I had safely locked the double set of gates. Moon never moved from his position, just watched me with a kind of satisfied grin that seemed almost lustful. I'd seen that same look once before, the only other time I was ever bitten, a far more serious incident with an Arctic wolf, another situation I had created not out of ignorance, but wholly arrogance. That was years prior, when I was a volunteer for the organization, and another opportunity I gave away.

That time, I was visiting Snow after working hours. While this was allowed, it meant no one else was in earshot, leaving me vulnerable. Strike one. Strike two: despite my knowledge of Snow's notoriously mischievous behavior, I failed to bring a shovel into the habitat—a tool that could be used as a barrier between human and wolf, if needed, but never to harm. I would realize strike three—no radio—only when it was too late. Though he was raised at the sanctuary from a pup and was relatively well socialized to the point that he even enjoyed human contact, Snow had bitten people before, and at about three years old, he was in his prime. In wolf lives, that's the sweet spot of adolescence when pups becoming adults are testing other pack members to see where they stand.

I can recall the exact moment I saw something

change. I had been petting Snow, which I thought he liked, until he walked away, only to return with an enormous grin, and a flash in his sunny amber eyes that bore his full intentions. The sanctuary was silent except for the occasional caw of ravens and the gentle bow of trees against the wind. I could hear his thoughts. I knew he was going to bite me. Calmly, I attempted to retreat, but was too far from the gate when he lunged, grabbing my right arm. I yelled and tried to make myself bigger, to appear imposing, but that only seemed to further entice him, because next he snapped at my right thigh, ripping my jeans and drawing blood. The energy was ratcheting up, and Snow was clearly getting excited. In quick succession, he snatched the loose fabric around my abdomen and began pulling me by my zip-up hoodie farther into the habitat.

All of this was instinctive, all of it the way a wolf would take down prey in the wild, first buckling the limbs, then going for the gut. I concentrated on staying on my feet. I knew what could happen if I didn't.

I had forgotten my radio and couldn't call for help. I continued to yell, but that served me nothing. By this time, all of the wolves in the neighboring habitats were wildly pacing their fence lines and howling as they watched and gossiped about what unfolded. Snow let go of my shirt and grabbed my left arm, tearing fabric and flesh. More blood. With his jaws engaged I was able to unzip my sweatshirt with my right hand and throw it toward him, hoping this would satisfy him. It did. He let go and eagerly seized his prize, running it to the back of the habitat, where he proceeded to shred the sweatshirt with glee. Royal blue cotton spread around him, almost comically, like the thick cloud swirling around the Tasmanian devil.

I escaped with minimal injuries. That was, until the morning I turned my back on Moon. I was lucky again only to receive what I would call a gentle warning; wolves have incredible control over their jaws, and neither had inflicted their full force on me. Though they certainly could have.

Again, my arrogance, not my ignorance, had done me in. I had the rules so well memorized I could recite them if asked. One of those being: never turn your back on an animal.

I can look back now, almost two years to the date, and see that I was both overly confident and distracted. My husband and I were weeks away from leaving the sanctuary to backpack through Asia for the following six months. We didn't know what we would do or where we would go once we returned, and all the tension of leaving our jobs, home, securities, and comforts behind us was mounting. This anxiety was half of what caused me to turn my back on a wolf. The other half was simply my belief that I was experienced enough to bend the rules without consequence. I slipped up, and got caught displaying the very arrogance that led animals like Moon and Snow into captivity in the first place—I overlooked their wildness. And for that, I paid, just as we are all paying for our unwavering belief in human dominance. The destruction of our wilderness has undoubtedly led to something else, too: that is, the fundamental loss of our individual wildness.

At the sanctuary, we called this complacency syndrome; a bite was always regarded as the result of human error. Complacency syndrome was something we warned each other against: never get too comfortable, and never underestimate the wolves. After all, they are wild and unpredictable, whether they were born into captivity or not. We are always to respect their nature, and we were trained to expect the unexpected, to be ever-present, and to never be caught off guard.

My mistakes left me with two faint scars and a much deeper lesson in boundaries, including the realization that I had invited Moon to violate mine.

As caretakers, the onus is on us to be attentive and follow the rules, thereby avoiding any altercations with the rescues. Further measures are also taken such that only the most experienced staff members care for the highest-risk residents, like those with a history of aggression. For their part, the animals are never expected to be anything but what they are: innately wild yet captive wolves and wolf-dogs living in a fundamentally unnatural state.

In response, staff and volunteers are taught to respect the boundaries of the animals, to never impose socialization on the rescues, and to always let them dictate their level of comfort with us. At the same time, we are to assert our own authority, to take control over our tools and our bodies, and to never allow the rescues to take advantage of us. That means knowing how to avoid creating opportunities for them to do so, as I had when I turned my back on Moon and when I entered Snow's habitat without a tool or radio after hours.

But my boundaries were also personal. Over my time at the sanctuary the daily practice of upholding boundaries taught me to put up the necessary walls

to protect my inner sanctity. I slowly gained the confidence to allow relationships that weighed me down to fall away. I stopped inviting people to take advantage of me and confronted troubles plaguing the relationships I cared for most. I set boundaries around my artistic time and quit giving in to social pressures, letting go of what was no longer important.

All this created the space to rediscover and reconnect with my own inner wildness, a wildness that we all crave but that seems increasingly tamped down by our modern world. Our complacency in the status quo, often leading to stagnation, is much a part of that.

In canid anatomy, jaw pressure is indicated by the size of the animal's sagittal crest, a pointy ridge crowning the skull. This helmet-like peak at the sagittal suture is found in many species of mammals and reptiles that rely on powerful jaws to catch their prey. And while a wolf's jaw pressure is a major asset, jaw pressure in humans is often associated with pain, affliction, and malady. The National Institute of Health estimates that approximately ten million Americans suffer from TMJ, or temporomandibular joint and muscle disorders, characterized as jaw tightness, clicking, clenching, grinding, soreness, and the like.

Jaw pressure is all about gripping, clutching, and holding on, especially for predators like the wolf who rely on the strength of their mandibles for sustenance. In this way, our mouths serve as a physical gateway between our inner and outer worlds, a literal boundary through which we can speak our truth, nourish body and soul, and express our affection for others. Yet tight jaws in humans are often a sign of stress exhibiting itself in the body, a physical manifestation of an inner constricting likely corresponding to a feeling of violated boundaries in one's outer world.

Like the sanctuary's wolves, each living in a landscape not suited for them, we are all caged in some way, by our beliefs, bodies, societies, jobs, fears, religions, relationships, finances, or other life circumstances. To break through those bars requires us to reconnect with our deepest, wildish selves, beginning with the unleashing of our own inner voice, our purest howl. ❧

TRAVIS TRUAX

Driving Oklahoma Is Rarely Met with Much Excitement

but some of us know a distant storm
means the creeks will soon boom with song.
And we smile, knowing this wide sky
isn't empty, turning our tallied miles
into stories—each one a different myth.
One we call scissortail, for its streaming feathers,
its tale of division and grief: how a body can both
split and stay behind. Driving these roads,
we love the prairies. We love the underpasses
putting distance in a frame. And we love the way
the sky talks about tomorrow with the clouds,
how the calm swarms of starlings pass by:
a thousand dots, black against blue, a flock
of quickened hearts spilling in the open space
above the cattle.

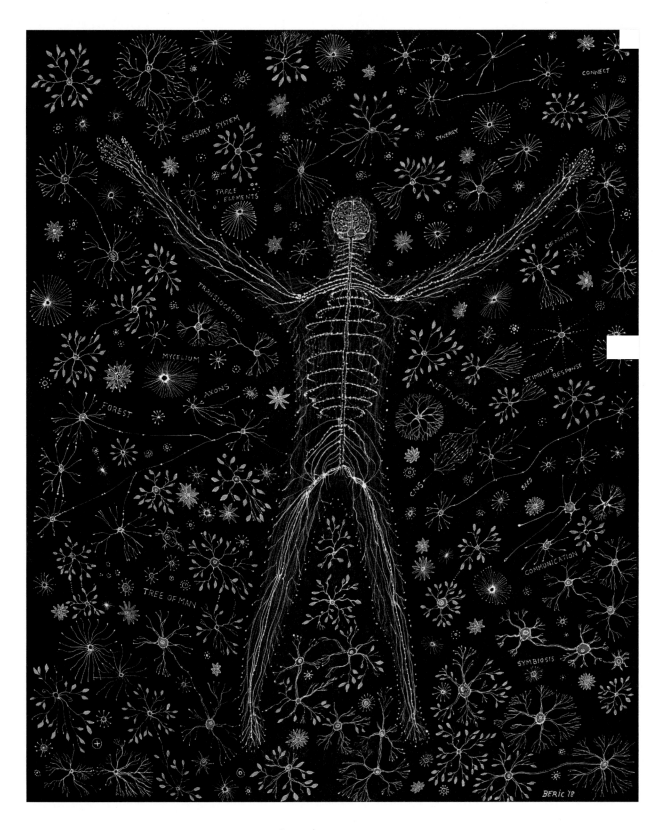

Tree of Man | BERIC HENDERSON
Acrylic and ink on paper, 30 x 39 in., 2018

ANTHEA YIP

Plant a Human | FICTION

"PLANT A HUMAN!" blares before my eyes in red and peach color. Saturated, fake-shiny, moist skin, and a fully functioning nose. What lies! You can't go around the park and see any human in this condition anymore. They're all either really old, with skin folding into flaps and broken noses, or reduced to stumps: feet and calves, the rest chopped off. That's the real state of things.

I bend down, engulf the first rock on the road in my pink rubber hands, and throw it against the advertisement. It glitches, and the colors seem to fade, only a bit. My stomach rumbles and complains incessantly like a child. I haven't eaten a thing for a week. Neither has anyone else on the street next to me. We're all half bent over our silicon glossy peach bellies, our muzzles up in the air in resignation. All this pollution drives me crazy. We cough and wheeze our way through the day, crawling for precious carbon dioxide to keep our bodies working like hungry hyenas. Our eyes barely see past the fog of oxygen.

I spend half a day wandering, like all the others, submerged in gray fog, hands in pockets, bumping our huge amorphous bodies into each other. All we can do is wander. Wander in hope of food and carbon dioxide, and curse this planet for its failure on us.

It wasn't like the good old days, when our planet flourished, rich with crops and humans living healthily in their fields and forests.

The first human spaceship crashed on our planet a thousand years ago. The humans were aiming at a better place to settle—one which other beings did not inhabit already—after the probable destruction of their home planet. And so, they adapted the only way they could. The heavy nitrogen atmosphere caused their lower body muscles to freeze up, making them immobile yet still alive due to a small percentage of oxygen in our air. When they were discovered by the first Edixiods, they were mercilessly tortured and killed. Blood flooded the streets. We are very territorial, probably the most territorial race in this solar system. It soon became a

tradition to dry out human limbs and arms, roll them in paper, and smoke them. Smoking a human seemed to have a hugely ecstatic effect on the nervous system.

This went on for centuries, as humans were bull-dozed and chopped up and sold for enjoyment. It was only a decade ago that things changed: we all knew our planet was far from perfect, and there would be a time it would crumble over our pressure. Its natural carbon dioxide atmospheric layer was bound to deteriorate at the fastest speed compared to any other planet. Air was thinning out very rapidly. We had predicted that our species would be doomed in another hundred years. We were wrong; now, our doom seemed to be coming in a mere ten years.

In the midst of panic, with all Edixiods wheezing for life, trying anything and everything to find a solution for salvation, we discovered that humans could be our saviors. Desperate scientists had taken in a sample of our human invaders for study, hoping to find a solution, *anything*. And what they found became the discovery of the decade. Humans breathed out carbon dioxide, faintly and very subtly, but they did nonetheless! No one had ever bothered to investigate the "enemy."

With this discovery, human agriculture started up. Big companies grabbed for the best genetically adapted humans, and the carbon dioxide market boomed. This lasted for around five years. Yet, the number of humans remained scarce—they were already near total extinction due to the constant extermination and persecution from the past.

As our population increased, so did the greed and the corruption. On that aspect of emotions and irrationality, we seem incredibly human. The need for having a personal human so that we could stay alive caused a crisis. There were too many Edixiods for the dying planet to feed, and the humans were dying from exhaustion. Soon enough, another strategy had to be put in place. Humans were to become public property, planted in "breathing areas," accessible to all Edixiods

at a certain price. There were no longer enough humans for all.

Thus, the park is where I will most likely find my carbon dioxide meal of the week. It's a popular tourist attraction for Edixiods. Huge banners scream with fake accents: "Live, Human, and Growing!" "The Amazon Human Forest: Restored." There are two fully grown adult humans, with working noses and all, in the park. And that's about it. That's the "Grand Forest." They breathe in our oxygen, and carbon dioxide comes out of their lips: as precious to us as diamonds.

There's always a queue in this park. To stand in front of a human, the waiting time is always around three hours. The stench of desperation fills the whole field like dirty dishes. And for the lazy ones who don't want to wait, the park sells overpriced bottles of carbon dioxide to inhale on the go.

Over-indulgent, excitable chatter sprouts here and there as I weave my way through the crowd, clumps of oxygen getting stuck at my nostrils, causing me to wheeze further. The Edixiods congest around the humans, which at this point just seem like fossilized pillars of lifeless matter. I'm swayed and pushed around to the beat of the rushing footsteps and waves of the queue as it lurches forward, slowly yet violently. I cough again, almost troubling to find clean carbon dioxide between the crowds.

"Buy a ticket!" rings every minute as a seemingly homeless Edixiod comes around in a box, collecting money, licking his lips, and giving out tickets. His eyes automatically scan the crowd with no mercy, as if his sole identity and purpose was to find those trying to get in without paying their fee. At some point, I realize the change in oxygen has probably gotten to my head because, without any reason at all, I join the queue of Edixiods for the "Meet and Greet Humans." The queuing Edixiods are all either desperate for some kind of enlightenment given by humans, are simply there for a gasp of clean air, or—just because they had never seen a live human—are planted before them, their nails still intact, eyes still open.

Our longing for what we've destroyed is disgusting.

I look down at the five-year-old Edixiod next to me. Maybe for a second too long, because his mother glances at me and explains:

"He wanted to see a human for his birthday."

By the time I get to stand in front of a live human, my limbs feel broken. Was this even worth it? But my mind's too sluggish to even answer its own ponderings.

"So here we are, you and I," I whisper, almost shamefully. I straighten my back, cough, and place my gaze on her two feet. Her body is sturdy, and hair sprouts thickly from atop it. My eyes crawl up her aged skin, shriveled and scaling. I reach her face, with some difficulty, and notice how it has been carved and worn down over time. Eye-bags weigh down on her slitted pupils, and her eyelashes are an ashy color. Then, as if by some ancient rusty mechanism, she moves her left arm and takes my wrist with her frigid fingers. Without saying a word, under her grasp, I understand she is telling me to leave.

I do as she instructs me. I let the little Edixiod behind me go ahead and enjoy, savor her moment with a human.

"I want her to touch me too!" the little creature screams. I pretend not to hear and walk away. My feet are on autopilot, and I let them lead me to wherever they choose while my brain scrambles to make sense of the encounter. After half an hour of walking within the park, it is next to a huge fossilized human remain that I find them. A group of adolescent Edixiods in a circle, all wearing baggy clothes. They offer me a rolled-up piece of paper, stuffed with some unknown material. They take a glance at me, as they sit cross-legged, leaning against the human legs, and one of them juts his arm towards me, offering me that rolled paper. Dried pieces of human limbs spill out of the blunt.

"It's made out of the best quality of human. 100 percent biological."

I take it and sit down next to them. I inhale twice. I hold it in for a few seconds longer.

My eyes snap shut like blinds, and my heart thumps, reverberating through the floors of my reality, shaking me off balance. By this time, I know I'm lying down. My body has been sucked of energy completely and shot me into an unknown space.

I feel the breathing bodies next to me, and I feel them shaking too, but with a knowing calmness. I close my eyes and the dream starts.

From above I see thousands of human heads, their bodies beneath: breathing, alive, full of adrenaline. I realize I am nothing, yet I have become everything. So I watch it all.

The humans shoot their eyes and arms up to the air.

Their pupils dance wildly, full of glory. Moving like waves, they inhale and exhale, their bellies hungrily expanding and contracting.

Breathless, I watch the force of nature, the exchange between soil and human roots.

Then I remember to breathe and I feel like I had never nourished my body with so much carbon dioxide before. The particles flow into me, with such elegance and ease. No cough. No wheeze. I stop breathing again when I find myself watching something I never knew humans could do.

In unison, they open their mouths, exposing rows of white gleaming fossil teeth and slimy red snake tongues. They start making sounds: beautiful, repetitive tunes, complicated yet elegant like a labyrinth. The pitches rise and crawl down low, raising the hairs on my back. Like a soft blanket, their voices permeate the whole atmosphere, and everything tastes sweeter. The humans stand up straighter, spines extending, kissing the clouds, showering under raindrops and burying feet further into soil. Their breath quickens, producing more and more carbon dioxide. I can sense it.

Then I scream as I'm grasped away from this reality. A hand snatches me and brings me forward in time to the same location.

Huge obsidian machines apathetically crunch over, grind and slice humans without stopping. That's when I hear the first human scream. Their blood is as red as I've ever seen, redder than rose petals or blood oranges. It's the pain that tints it with this intensity. Humans fall over, screeching, tears flooding the soil into rivers. They grasp for those around them, they call out for their mothers. And yet the machines march on. I see the bare ground now. Stripped naked of its hosts. And suddenly, I'm back to coughing, wheezing.

I wake up the next day, still with the group of Edixiods, in the park. The morning star hasn't risen over the horizon yet. For a moment, I just sit up and breathe in the pure carbon dioxide, untainted yet by the desperation of throngs of Edixiods inhaling. Opening my eyes, soft mist kisses my face and settles just above the grass. The humans stand tall, alone finally, in their sleep. They seem to spread their arms and legs farther apart, taking up more space in their little bubble of intimacy.

Silence engulfs the place like a motherly blanket, bringing subtle serenity in the desolated park. I hear myself breathe, and I hear the humans breathe.

Savoring this moment, I prop myself up, knowing what to do already. I sprint quietly, to not bother all the beings in their light sleep. I pass the "Meet and Greet" sign, remember exactly the path to that human I met yesterday. And when I reach her, my heart starts to beat, whispering its little explosions in my eardrums.

She snaps her eyes open. I scan her skin cells; the color between beige and peach is inimitable. My silicon arms start to shake as I move my pupils up her body, exploring. Finally, and daringly, I look up into her eyes. Dark hair falls by her face, snaking around her temples, forehead, and down her shoulders and arms, whispering by her back like a guardian.

But her gray eyes look like concrete: something in them feels almost dead, like a switch turned off. At the same time, like a dagger, something else in those pupils manages to cut through my flesh and reach into my heart. I stand there, tied to her, immobilized. I don't dare touch her. We both tremble in trepidation. She's alive. For the first time, I see life in her.

This time, when she extends her arm, she does so smoothly, not like an oiled machine, but like a living, breathing, sentient creature. I see her muscles contract under her smooth skin. She holds my hands.

I showed you all that you needed to see, her hands seem to say. Languidly, as if with dread, she lets her arms climb down to her opening, and as she forces a hand in she sheds a tear. I watch her choke and gasp, her fingers starting to drip with a vehement red liquid. It's the holy sap that has been spoken of in textbooks: blood. She then forcefully extracts her hand, and extends it towards me. In the palms of her hands she holds an embryo. She places it in my hand, and a second later, she screws her eyes shut, bending over.

Her scream lacerates the whole park. Now on her knees, she rests her whole body on the floor, shaking. She looks at me one last time, and I know what she wants me to do. Her grip on her breast loosens, her face relaxes, and I know she has passed.

I can't take it. I'm up and running. My throat's clogged and I forget to breathe. Tears start rolling down my cheeks and I feel them slide down my skin and into my mouth, diffusing as salt down into my lungs. I grip the embryo harder. It's still soft and beating.

My head's spinning when I find a spot at the back of the park. My hands are tired. Soil crumbles through my fingers as I dig and dig. ❧

Nestling | BERIC HENDERSON
Acrylic and ink on paper, 20 x 20 in., 2017

Off-Base | NONFICTION

THIS BEACH IS A SUSURRUS of shorebirds. After half a week on this temperate coast in the waning days of winter, the finely grained diversities of wing delight and delude me. They seem vast and billowing, clouds upon the sand.

Their numbers are small, compared to the massive musters before some of our own species' worst inventions—habitat theft, massive water pollution—began to show their colors. My shifted baseline lets me see the flocks as great, and I walk among them humbled. It's an individual blessing as much as a general curse.

It's hard to get lost out here: Point Loma to the west, Tijuana south, one long stretch of curving flat sand, several visible sections of which belong to the US military. I rather miss the quickened breath of uncertain direction, the apprehension of mystery that comes with the unmaking of name and landmark, the erasure of empire.

Yesterday the birds failed to startle as I stepped between two feeding flocks. Close enough to appreciate the overlap of individual feathers, close enough to peer toward dark liquid eyes, I stopped, and meant to settle to the sand.

Birds in flocks—like fish in schools—respond minutely to the cues of their neighbor, and the results include what happened just then: everyone took off at once. If they had been two flocks, they were one in that moment, and winging so intensely to left and right and above me that I wondered why I had not also flown. Seafoam rushed in, seconds later, sliding the sand out from beneath my soles. I fell to my knees, glad for the direction of dirt.

But mostly the birds allow me to observe from a modest distance. Sometimes they're throwing multi-family feasts, all you can catch. Sometimes they keep to themselves. I quite understand the desire for both at once. If I don't yet comprehend the fine distinctions between a whimbrel and a dowitcher and a godwit, fellow-feeling is enough.

The plovers, though! An easy ID, and a special case, for the same reason kittens and babies are universally adored. These tiny gray-and-white puffs sport huge black eyes, inked-on eyestripes, and cartoonishly quick legs. They're perpetually in motion, striking the wet sand with their small neat beaks like black lightning. Very soon now they'll start to nest, choosing a shallow scrape in the sand by rules we can't control. Their internal guidance routinely ignores human habits. Their perfect scrape might be, for example, a day-old footprint on a heavily trafficked beach.

Snowy plover nesting grounds are protected here on the base at Naval Air Station North Island. A section of beach is roped off and signed: no dogs or humans allowed. It's immediately next to another don't-tread-on-me zone—this one warns of live rounds firing.

Burrowing owls claim homes here too, in the sandy tangle of low-slung weeds across the access road. They are also protected, by the dubious virtue of living on a radar range. Humans are advised not to wander here either, so I've stood my hopeful watch each day on the tarmac, pacing awhile and then sitting a spell, and finally giving up to try later. The owls are meant to be diurnal, and the few left in San Diego County stay year-round. Though I am here for them, I'm pleased with their indifference. They are not here for me.

There are no owls in sound or sight again this morning. I walked out to the waves instead, through zipping plovers and the daily 0800 hours strains of "The Star-Spangled Banner." Which feels . . . complicated.

I've spent my whole life on and off military bases. They're a comfortable species of home, for nomads like me, raised in regular migration from one to another. And they are one of our cultural blind spots, a fine place to observe our awkward attempts at balance. Our half-truths, too, and our outright lies. This place, for example: what a beautiful landscape, uncluttered by high-rise condos and expensive resorts. And it's offering legal protection, to particular migrants and natives alike, who share this land.

Note that modifier, though. Because the range of

folks, human and non, of which this place approves is not a broad one. Whatever beauties, diversities, and rarities abide, the base's purpose tolerates theirs, at best. Owls, plovers, the American taxpayer, the echoes of native humans who sing the things I love with different notes: all are subordinate here, to the great and terrible beauty of Our Purpose. Which doesn't share, not if you expect to be equally regarded. Chances are, "our" doesn't even include you. The central problem should be as easy as the plovers to pick out: we think we own all this.

And we rank our right to own and use above all else. We expect the land and sea, and humanity, to treat whatever bargains we've imposed as fair. Experience and compassion both teach that our supremacy is a damaging untruth. Meanwhile, my heart swells at the rockets' red glare.

Some people pray every morning. I know a few who meditate. I have to be prompted to do anything so mindful on a schedule. So I'm grateful to the distant loudspeaker, for tangling me daily in the messy soul-business of colonial culture. And for gifting this to me as a practice, rather than an ambush. Most of the time, it's my dubious privilege to forget. The road to hell is paved with such forgettings, with willful blindnesses and righteously offended ears.

Understand, I do not speak of some imagined eternal fate.

Damp sand, recently deserted by breakers, lies strewn with gifts. Thumbnail-sized shells in ice-cream-cone swirls, jet-black scalloped ones, whole sand dollars still furred with recent life. I made my beach offering thinking of nothing but this, as is proper.

It's not a picture, exactly, though it involves the visually pleasing arrangement of found elements. It's a tribute to impermanence, I guess. On every beach I wander, even if it's the same one every day, I find what I find, and then I give it back, as a piece of human art sourced in the generosity of ocean. It's possible no one else will see it before the certain reclamation.

I have been walking barefoot here for days—a thing my feet mostly do not tolerate, and I deeply miss. But sand is so forgiving. I've let my long hair down to sway in the slight salt breeze. The feeling altogether is near to mythological. I am kin to ancient beings of salt and seaweed, or ripple-haired heroines of nearer-term song and story. Or possibly just myself at an age when such comparisons came without embarrassment. I wasn't rational then, and it's a delight to reclaim my wild romanticism now, here in this place that knows, beneath the boots and the patriotism, what it's always been.

Back indoors, of course, I need a comb. That's wind and salt for you. I sit in front of the infinity mirror and imagine those shadows curving away behind my own reflection.

The ancient one does not need to see herself from the outside. She glances at the comb with interest, lets it lie. Order and shelter are not her elements. She collects a shawl of mist and wanders back to the sea.

The heroine is briefly surprised at the quality of her reflection. She sets to work grimly picking out the tangles, but the temptation is strong to cut her storied locks right off. She grumbles this to my flax-haired younger self, who stores it thoughtfully for later and takes her comb away, in search of our mother.

In the body I know, I lay my comb aside, and lie on the bed with the breeze astir through the wooden blinds. I float awhile, on the sound of surf and shorebirds, on the anchoring cry of the buoy in the harbor mouth. On the complex knowledge that I do not own this place, its other creatures. And that, also, this place is mine—through privilege, luck, and temporary sufferance—and I must wrestle all of those things, together with the rest of my species, to find the way forward.

I float, too, on the fear and the hope that nothing beyond this moment can be expected. And in this moment all I am is home. ❧

DAVE SETER

Stopping by Bombay Hook

My eyes unsure—from looking up too fast—
a single speck could be a bald eagle.
Reports of sightings drew me to wildlife refuges.
I'd perch in tree stands abandoned by hunters,
too desolate and cold even for their aching bones.
But chance is odd. Stopping by Bombay Hook
on a whim, my old haunt on the Atlantic Flyway,
a bald eagle shot across the sky to join another.
Two specks now tumbled in dance. In myth. In sky.
In dalliance. Where had I heard that word before?
Never mind, I was in love and lost to blinking
at ghosts, but existence is a funny thing, a list
of groceries, lovers, and eagles. They were mine:
I dropped my eyes to jot them—quickly—down.

Lauren Camp

Lauren Camp is the author of four books. Her poems have appeared in *Poem-a-Day, Slice, The Fourth River, Terrain.org, The Cortland Review*, and elsewhere. She received the Dorset Prize and the Anna Davidson Rosenerg Poetry Award, and she has been a finalist for the Arab American Book Award, the Housatonic Book Award, the Lascaux Prize in Poetry, *Best of the Net*, and the Auburn Witness Poetry Prize. Find her on Twitter @poetlauren or at laurencamp.com.

Erika Connor

Erika Connor is a writer and artist from Quebec, Canada. Her work with wild birds, travels by horse in Africa and Mongolia, walking the Camino, and other experiences are synthesized in her art shows and writing. She has published in *Travelers' Tales, Touchwood Editions*, and *Gravel*, and she is working on publishing memoirs, illustrated novels, and children's stories.

Erin Conway

Erin Conway is an experienced educator and nonprofit trainer with ten years of cultural experiences in Guatemala. She resides on her family's farm in Wisconsin and works with local organizations on issues of diversity that include seeds and soils. Erin's writing is an intersection of family histories and modern-day challenges.

Janine DeBaise

Janine DeBaise's poetry and creative nonfiction have appeared in *Southwest Review, Portland Review*, and *Orion*. Her poetry chapbook *Of a Feather* was published by Finishing Line Press. She teaches writing in the Environmental Studies Department at the SUNY College of Environmental Science and Forestry.

Elizabeth Dodd

Elizabeth Dodd is the author of two collections of poetry, most recently *Archetypal Light*, and three collections of nonfiction, most recently *Horizon's Lens*. She teaches creative writing and literature at Kansas State University.

Ryler Dustin

Ryler Dustin is author of *Heavy Lead Birdsong* from Write Bloody Publishing. His poems have appeared in *American Life in Poetry, Gulf Coast*, and *The Best of Iron Horse*. He holds an MFA from the University of Houston and a PhD from the University of Nebraska-Lincoln and has performed on the final stage of the Individual World Poetry Slam. His website is rylerdustin.com.

Beric Henderson

Beric Henderson is an Australian artist with a background in art and science. He has exhibited consistently since 2003, including in international shows in Seoul (2006) and Venice (2019). Henderson has won art prizes, lectured on creativity, and published his art in magazines and books and on a record cover. His website is berichenderson.com.

Talley V. Kayser

Talley V. Kayser directs The Pennsylvania State University's Adventure Literature Series. Her poetry and nonfiction appears or is forthcoming in *Hawk & Handsaw, Weber,* and the Shaver's Creek Long-Term Ecological Reflections Project. In 2019, Talley received a Kyle Dempster Solo Adventure Award. She will return to the High Sierra this summer.

Nikki J. Kolb

Nikki J. Kolb is a writer of fiction and nonfiction. She holds a BFA in writing, literature, and publishing from Emerson College. In preparation for her forthcoming novel, Nikki spent two years studying wolves as the program director at a wildlife sanctuary in the mountains of New Mexico. She now lives in rural New Hampshire with her husband and son, where she works in organic farming. Her website is knowstoneunturned.org.

Ted Kooser

Ted Kooser's most recent book is *Kindest Regards: New and Selected Poems* from Copper Canyon Press.

Paul Anthony Melhado

Paul Anthony Melhado is a Jamaican-born artist of Portuguese descent. He has been a Queens resident for over forty years and holds degrees in psychology, education, and art. His photographic technique involves the use of late nineteenth-century equipment, such as the view camera, and early twentieth-century processes that utilize film with traditional darkroom printing. His website is paulmelhado.com.

Shelby Newsom

Shelby Newsom is a writer and editor residing in Pittsburgh. She is the assistant editor for Autumn House Press and a fact-checker for Creative Nonfiction Foundation. She received her MFA with specializations in poetry and publishing from Chatham University. Nominated for *Best New Poets 2018*, her work has appeared in the *I Scream Social* anthology, *Flyway: Journal of Writing and Environment*, and *Pilgrimage Magazine*. Her website is shelbynewsom.com.

Emily Paskevics

Emily Paskevics is a writer and editor living between Toronto and Montreal, Canada. Her publications include the poetry chapbook *Rogue Taxidermy* (Dancing Girl Press, 2014), along with poetry, essays, and short fiction in *Hart House Review, Vallum Magazine, CLASH Media, Rogue Agent, Dark Mountain*, and *The Journal of Wild Culture*. Find her on Twitter @epaskev or at emilypaskevics.com.

Sarah Platenius

Sarah Platenius's art and writing explore how the interpersonal intertwines and reflects the tangible, touchable wilderness. She is currently paying attention to how the domestic and mundane juxtapose with the empty and timeless. Sarah lives in Tofino, British Columbia, with her husband and two kids. Her website is barefoottofino.com

Htet T. San

Htet T. San is a Myanmar-born artist based in New York. She works with visual art, photography, and installation. Her work explores ideas of identity, existence, memories, nostalgia, and human experience in a meditative and contemplative manner. Recently, she has been combining the visual concepts of installation, video projections, and sculptural/material mediums with traditional darkroom and digital imaging techniques. Her website is htettsan.com.

Dave Seter

Dave Seter is a civil engineer and poet. Originally from Chicago, he currently lives in Sonoma County. His writing has appeared in *Paterson Literary Review, The Evansville Review, Palaver*, and *Confluence*. He studied ecopoetics for his graduate degree at Dominican University of California. His poetry chapbook, *Night Duty*, was published in 2010 by Main Street Rag Publishing Company. His website is daveseter.com

Tara K. Shepersky

Tara K. Shepersky is an Oregon-based taxonomist, poet, essayist, and photographer. She lives for the turning seasons, pre-dawn walks, and the whims of her tuxedo cat, d'Artagnan. Recent work has appeared or is forthcoming in *Whitefish Review, Camas Magazine*, and *Shark Reef*. Find her on Twitter @pdxpersky or at pdxpersky.com.

Meredith Stricker

Meredith Stricker is a visual artist and poet working in cross-genre media. She is the author of *Our Animal, Tenderness Shore, Alphabet Theater, Mistake*, and *Anemochore*. Her work will appear in the *2019 Best American Experimental Writing* anthology from Wesleyan University Press. She co-directs a visual poetry studio, a collaborative that focuses on architecture in Big Sur, California, and projects to bring together artists, writers, musicians, and experimental forms. Her website is meredithstricker.com.

Susan Solomon

Susan Solomon is a freelance paintress living in the beautiful Twin Cities of Minneapolis/Saint Paul. Her work features Earth and the creatures with which we share the planet. Susan's work is in the university collections of Metropolitan State and Purdue. She founded and cartoons *sleetmagazine,* an online literary journal.

Travis Truax

Travis grew up in Virginia and Oklahoma and spent most of his twenties working in various national parks out West. A graduate of Southeastern Oklahoma State University, his work has appeared or is forthcoming in *Salamander, Quarterly West, Bird's Thumb, The Pinch, Raleigh Review*, and *Sonora Review*. He lives in Bozeman, Montana. Find him on Twitter @travis_truax or at writingfromhere.org.

Rebecca Stetson Werner

Rebecca Stetson Werner lives in Portland, Maine, with her husband and three children. With a background in child psychology and research, she writes about parenting, environmental issues, and life in their very old home. Her most recent writing has been published by *Maine the Way, Taproot*, and *Full Grown People*.

Anthea Yip

Anthea Yip is a half-Italian and half-Chinese artist, writer, and spoken word poet, currently based in Hong Kong. Her writing has appeared in blogs, literary platforms, and printed poetry collections, and is forthcoming in the anthology *Mingled Voices 3* by Proverse Publishing. Her artistic work has appeared in An Extraterrestrial in Hong Kong, sponsored by the Hong Kong Arts Development Council, and *Cha: An Asian Literary Journal*. Her website is antheay.com.